The Art of
iPhoneography

The Art of iPhoneography

A Guide to Mobile Creativity

Stephanie Calabrese Roberts

ILEX

First published in the UK in 2012 by
ILEX
210 High Street
Lewes
East Sussex BN7 2NS
www.ilex-press.com

Publisher: Alastair Campbell
Creative Director: James Hollywell
Associate Publisher: Adam Juniper
Managing Editor: Natalia Price-Cabrera
Editor: Tara Gallagher
Specialist Editor: Frank Gallaugher
Senior Designer: Ginny Zeal
Design: JC Lanaway
Color Origination: Ivy Press Reprographics

British Library Cataloguing-in-Publication Data
A catalogue record for this book is available from the British
Library

ISBN: 978-1-908150-89-9

Printed and bound in China

10 9 8 7 6 5 4 3 2 1

CONTENTS

iPHONE CAMERA BASICS 8

Start by understanding the basics of the iPhone camera, and learn to shoot, organize, access, back up, and share your images using the native camera and photo library.

CRAFT YOUR TOOLKIT 14

Expand your creative shooting and image-processing capabilities by experimenting with a collection of applications ("apps") that you can download. We'll introduce you to several popular photography apps and key features, and offer step-by-step guides to help you master them.

SPARK YOUR CREATIVITY 56

Open your eyes and start shooting. Choose from 100 secret missions to spark your creativity and discover opportunities for images to emerge. Share what you find by contributing your images to our online Art of iPhoneography image gallery.

SHOOT HOW YOU FEEL 74

Your vision subconsciously influences what you see and how you shoot. But can you see beyond the subject matter? In this chapter, we'll practice seeing in a more conceptual way by asking you to define images by how they make you feel. Then we'll challenge you to shoot how you feel to help you uncover your inner vision.

FIND YOUR FOCUS 100

Now that you've stretched your creative boundaries, it's time to add some focus. In this chapter, we'll trace the paths of iPhoneographers from around the world and study their unique approaches, techniques, and iPhoneography projects that demonstrate their vision. They'll undoubtedly inspire you to define a personal project to help you find your focus.

JOIN THE COMMUNITY 142

You're not alone. There's a growing community of iPhoneographers eager to share insight, experiences, and images. In this chapter, we'll offer guidance to help you create an online iPhoneography journal and show you how to connect with other iPhoneographers.

EXPLORE RESOURCES 154

This book is only the beginning. Explore a wealth of online resources to learn more about tools, techniques, and the art of iPhoneography.

CAUTION!

THIS BOOK WILL STRETCH YOUR VIEW

So what makes the iPhone camera such a powerful device?

- You rarely go anywhere without it, expanding your access to fleeting magic moments anywhere, anytime.
- Its slight size and weight makes you less obtrusive and more agile in natural, documentary settings. You can even shoot with one hand.
- The multipurposeness and simplicity of the device renders you harmless, making it nearly impossible for your subjects to take you too seriously. People are more at ease in your presence. This breeds spontaneity.
- What you lack in fine-tuned shooting control (i.e., no aperture and shutter-speed settings), you gain in speed. This lightens the weight of the moment by freeing you up to focus on composition and what's before you.

Now that you're convinced of the magic made possible by the iPhone in your hand, let's get started. In this book, we'll:

- Help you craft your photography toolkit by showing ways you can shoot, process and share images using a handful of simple-to-use apps.
- Offer you secret missions to spark your creativity on a daily basis.
- Challenge you to shoot how you feel, rather than just what you see.
- Share inspiration from avid iPhoneographers around the world.
- Inspire you to find your focus—to define a personal project unique to you.
- Encourage you to create a visual journal to share your experience and connect with fellow iPhoneographers.

AUTION! THIS BOOK WILL STRETCH YOUR VIEW

I'm glad you're holding this book in your hands—because it means that you have a desire to create something. I felt that same desire when I realized that my iPhone gave me the power to create art in a new way. It opened my eyes and stretched my creative capacity as a photographer. I hope this book does the same for you.

Let's start by defining iPhoneography as a type of photography. Like pinhole, film, or microscopic photography, we're focused on the act and art of photography defined by the device used to create the image. iPhoneography is the art of shooting, processing (editing and enhancing), and sharing digital images using an iPhone.

Whether you're a professional photographer, an enthusiastic amateur, or simply a curious person who has a desire to experiment with photography, this book is for you.

Think of iPhoneography as a simple, mobile method for making art as you move through life—at the very moment inspiration arrives. Think of it as writing loosely in a journal or making marks in a sketchbook. The intent of this book is to inspire you to use iPhoneography as a method of creative discovery and visual experimentation. IPhoneography can help you practice spontaneity, loosen up your traditional approach to photography, and stretch your view . . . ultimately making you a better photographer. I look forward to seeing what you create in our Flickr group, and hearing about your experience with this book. Stay connected with me at: www.artofiphoneography.com and http://www.facebook.com/artofiphoneography.

Stephanie

iPHONE CAMERA BASICS

For me, photography is less about the camera and more about the vision of the person behind the lens composing the view and pressing the shutter. While this book is specifically geared toward the process of making art with an iPhone camera, you could apply many of the ideas in this book to make art with any sort of camera. It doesn't matter whether your iPhone is an older one, or the latest and greatest version: using your mind and your heart as the guide, and a wealth of apps to apply your vision, you have the power to create artful images.

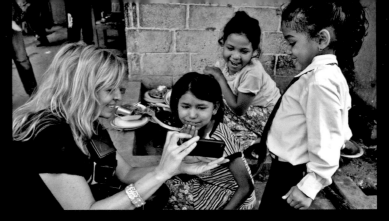

In this picture, I'm sharing iPhone photos and videos with children in Pokhara, Nepal. Photo by Jen Lemen.

About the Images and Screen Captures in this Book

I shot and processed all of the images in this book exclusively with my iPhone 3GS, iPhone 4, and iPhone 4S. I used my iPhone 4S to create the screen captures and have featured the most up-to-date versions of apps and web resources available to me at the time of this book's creation. The functionality of apps and web resources described in this book and the operating system on your iPhone will naturally evolve over time, so if you find that the screen captures do not represent what you see on your iPhone or online, review online help or support from the app maker or website provider for guidance. Refer to the "Explore Resources" chapter for a complete list of resources referenced in this book.

The images in the "Find Your Focus" chapter were taken by other iPhoneographers, who also used the iPhone 3GS or iPhone 4. Only two of those iPhoneographers used Adobe Photoshop on their desktop to process select images (most processing was done with iPhone apps).

Shooting iPhone Photos with the Native Camera

Shooting with the iPhone native camera (the built-in iSight camera app on your iPhone) is the quickest method to shoot an image, and gives you the most flexibility with image processing, because it saves an original image at the highest resolution to your photo library. Using that original image, you can apply endless processing effects by using a variety of apps. We'll explore image processing in the "Craft Your Toolkit" chapter.

Photo Library
Icon

Camera Icon

To shoot:

- Tap the Camera icon.
- Tap the Flash button to set your flash to "Off," "On," or "Auto." (I most often set my flash to "Off" to avoid too-harsh light. I can typically adjust underexposed images using a variety of apps.)
- Tap the Options button to set the composition "Grid" and/or "HDR" feature(s) on. The default setting is "Off." Tap the Done button when finished.
- Tap the flip camera button to switch to the front-facing camera if you want to focus the viewfinder on yourself.
- Position the iPhone to compose your image vertically in the viewfinder, or turn the camera 90 degrees to flip to a horizontal view.
- Tap the area of the viewfinder where you wish to position your point of focus. Tap the viewfinder with two fingers and spread them apart or together to zoom in or out.
- Tap the Shutter button to shoot.
- The image instantly appears in the Photo Library preview. Tap the preview image to open the image in the Photo Library.

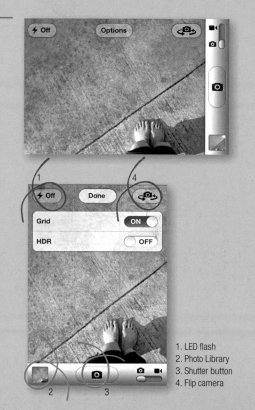

1. LED flash
2. Photo Library
3. Shutter button
4. Flip camera

FLEXIBILITY AND SLIDESHOW SETTINGS

One image shot with the native camera and processed in different ways using a variety of apps.

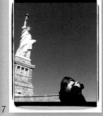
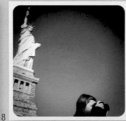
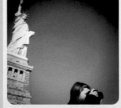

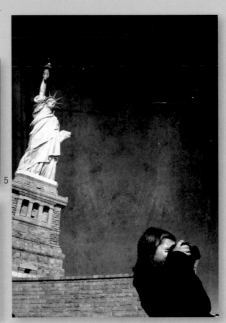
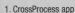

1. CrossProcess app
2. ProCamera app
3. Camera+ and Iris Photo Suite apps
4. Snapseed app
5. Camera+ and Iris Photo Suite apps
6. Snapseed app
7. Lo-Mob app
8. Photo fx and Instagram apps

Adjusting Photo Library Slideshow Settings and Options

You can adjust photo library slideshow settings to control the amount of time spent on each image in the slideshow, and choose to repeat and/or shuffle photos in the selected image sequence:

1 Tap on the Settings app.

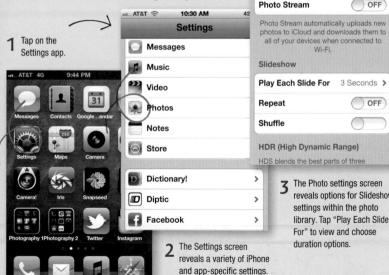

2 The Settings screen reveals a variety of iPhone and app-specific settings. Tap the "Photos" option.

3 The Photo settings screen reveals options for Slideshow settings within the photo library. Tap "Play Each Slide For" to view and choose duration options.

Adjust Slideshow Options

Adjust Slideshow Options to select the transition style, select and play music from your music library, and start the slideshow.

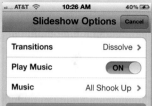

1 In the photo library, select Camera Roll or a specific album and tap on the photo you want to appear as the first in the slideshow. Subsequent photos will appear in the order listed in your Camera Roll or Album, unless you turn on the "Shuffle" feature in Settings. Tap the play arrow below the selected photo and choose Slideshow Options.

2 Tap "Transitions" to choose a transition style to appear between images in the slideshow. If you want to play music during your slideshow, turn "Play Music" ON and select a song from your music library. Tap the Start Slideshow button to play the slideshow.

PHOTO MANAGEMENT

Working with Images in the Photo Library

Shooting images with the native camera or another photography app on your iPhone will place images in the Photo Library. When you work with apps to process your images, you will access images from the Photo Library. In the Photo Library, you can also preview and select images, create a slideshow, copy, and share or delete images. Follow the steps shown on the opposite page.

Downloading iPhone Photos to Your Computer

When you sync your iPhone to your computer, it will automatically attempt to download images from your iPhone and import the images you designate into your primary photo management application (e.g., iPhoto, Aperture). It's a good idea to sync your iPhone frequently or consider using iCloud to automatically store and secure your images online (like a hard drive in the sky) so you can access them from any of your devices.

Selecting one or more images in the Photo Library

To select a single image:
Tap on the image. After several seconds, the top and bottom navigation bars will hide. Tap the image to reveal them.

To select multiple images:
Tap on the Select icon in the upper right corner. Tap on one or more images to select them. A check mark will appear on the images you select. When you are done, tap to share (email, message or print), copy, add photos to an album, or delete them. To deselect images, tap the Cancel button.

1. Select

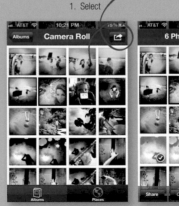

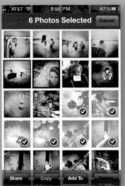

1 Open the Photo Library
Tap on the Photos icon to open the Photo Library. This will reveal a list of Albums. Tap Camera Roll to view images shot on your iPhone or an album you created using iPhoto.

Albums

Rotate Auto-Enhance Remove Red-Eye Crop

1. Edit Photo Tools

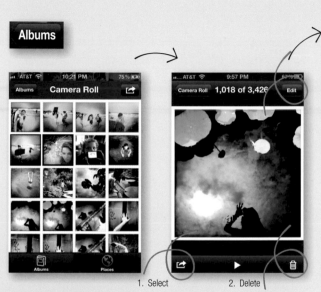

1. Select 2. Delete

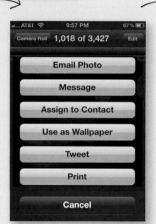

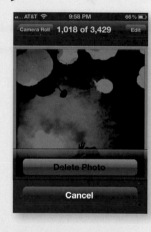

2 Browse Preview Photos
The Camera Roll will reveal thumbnail previews of your images. Swipe your finger up or down to scroll through the collection. Tap "Albums" to return to album options.

3 View Photos
Tap to select a photo and swipe forward or back to view images in chronological sequence. Tap the play arrow to choose Slideshow Options and start a slideshow presentation. Tap the current image to stop the slideshow.

4 Edit a Photo
Select a photo and tap the Edit button to reveal basic edit options for your image. You can rotate, auto-enhance, remove red-eye, and/or crop your image constrained to the original aspect ratio or select a new aspect ratio (e.g., 4x6, 8x10) to optimize for printing.

5 Share a Photo
Tap on the Select icon in the lower left corner to email, message, assign the photo to a contact, use the photo as wallpaper, share the photo as a tweet through your Twitter account, or print the photo using an AirPrint Printer if one is available.

6 Delete a Photo
Tap the trash icon in the lower right corner to delete the selected image. Confirm to delete the image or cancel.

CRAFT YOUR TOOLKIT

Just as a painter makes decisions about his or her creative tools—the size of a canvas, colors in a palette, or the shape of a paintbrush—you have a variety of iPhone photography apps and processing techniques at your fingertips to experiment with and shape the direction of your art. You might choose one camera app to shoot an image and another app (or several) to edit or share that image. Downloading and experimenting with a variety of photography apps on your iPhone is a good way to get started. In the end, you might find that just a couple of apps meet all of your iPhoneography needs, but when starting out, give yourself permission to experiment and expand your creative capacity. If features are similar among apps, you may find that you prefer one over another because of its intuitive user experience.

As a documentary photographer, the intent of my professional work is to make images that are true to life, so I have a light hand when it comes to processing images shot with my SLR camera. I might make minor adjustments to exposure or white balance, or convert a color image to black and white, but historically, processing has not been a source of creativity for me. I've taken the opposite approach with my iPhoneography, granting myself the freedom to explore a more abstract approach to shooting and a more liberal approach to image processing.

With my iPhoneography, I might crop subjects to the point of abstraction, over-saturate colors, or apply layers of texture, vignettes, and borders that mimic the effects of vintage cameras. My aim is to see the world through a different lens, one that doesn't need to reflect life as it is, but more how I want it to be in that precise moment. Because this approach differs from my professional documentary style, I share my iPhoneography in a separate online journal, like a sketchbook. I like the freedom of exploring two paths that may never connect.

In this chapter, we'll explore several popular photography apps. I encourage you to begin to build your toolkit by downloading one or more of these apps from the App Store on your iPhone and experimenting with them.

All images you shoot (with the native camera or any other app) will be stored in your "Photos" image library. When you launch an app and want to process an existing image, you will access the saved image from the image library. Try using just one new app each week so you can get comfortable with its capabilities before moving on to the next. And keep in mind that the apps listed in this chapter are just enough to get you started. For a comprehensive list of the most current photography apps, visit the App Store.

I position my most frequently-used apps on my primary iPhone screen, and in particular my favorite shooting apps, so I have quick access to them at all times. I might swap out a photography app on this screen if I'm interested in experimenting with it.

My Photography 1 category holds photography apps that I use fairly regularly. To create a category of photography apps, tap and hold on an app and drag it over another photography app. You can rename the category and store up to nine apps within it.

My Photography 2 category holds photography apps I use occasionally.

CRAFT YOUR TOOLKIT

SNAPSEED

Snapseed is an intuitive yet robust app, ideal for its flexible image-processing (vs. shooting) capabilities. I typically shoot documentary images using the native camera or the Cameramatic app (for square-format compositions), then often process these images with the Snapseed app to make minor enhancements—retaining a photograph that's true to life. Key processing capabilities include contrast; overall or selective adjustments for brightness; straightening and cropping (free or constrained to common dimensions); black and white conversion; vintage, drama, and grunge filters; center focus (to simulate a wide aperture setting by blurring the background); frames with variable width control and tilt and shift effects (linear and elliptical). I'm able to accomplish the majority of my image-processing needs with this one simple-to-use app.

Connect Online

Snapseed—http://www.snapseed.com/
Image Gallery on Flickr—http://www.flickr.com/groups/snapseed/
Twitter—snapseed

Add Drama, Center an Area of Focus, and Crop

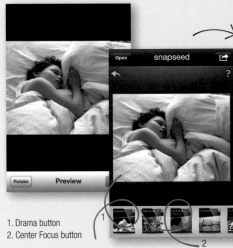

1. Drama button
2. Center Focus button

1 Tap to launch Snapseed, then tap the "Open" button to select an image from your photo library or "Camera" to shoot a new image. If you shoot a new image and are satisfied with the result, tap the "Use" button to reveal processing options in the toolbar. Keep in mind that the original image shot with the Snapseed camera will not be saved to your image library. Snapseed will save the edited image when you choose to save it during the editing process.

Snapseed Craft Your Toolkit

16 / 17

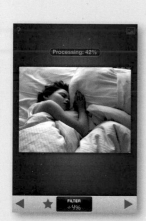

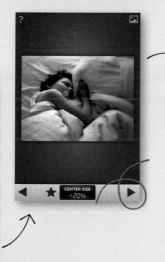

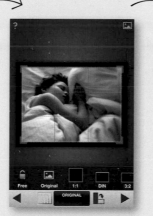

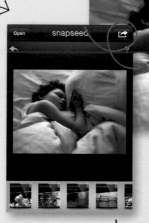

2 I tapped the "Drama" button in the toolbar to adjust tone and contrast slightly by slowly swiping my finger to the right, applying 4% of the filter. Satisfied with the look, I tapped the forward arrow icon to accept the effect.

Next, I tapped the "Center Focus" button, positioned the area of focus over my daughter's face, and slowly swiped my finger to the right to increase the diameter of focus to 20%. I tapped the forward arrow icon to accept the effect.

3 To eliminate the color beyond the sea of sheets within the upper right edge of the frame, I tapped the "Crop" button in the toolbar, tapped the boundary icon and selected the "Original" aspect ratio of the image, and positioned the frame over the image to crop out the upper right edge. I tapped the forward arrow icon to accept the crop.

4 Satisfied with the result, I tapped the arrow icon in the upper right corner to save the image to my photo library.

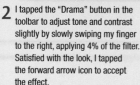

IRIS PHOTO SUITE

Iris Photo Suite offers comprehensive, professional-level image-processing features and control to adjust brightness, highlights, shadows and contrast; change color balance, saturation, and temperature; reduce image noise, and sharpen or blur your subject; and/or apply a broad range of creative effects spanning color and black-and-white filters, and artful, vintage, grunge, lo-fi, and textured effects. While I don't typically use this app for basic image adjustments to my true-to-life documentary images, it's an ideal app for creative processing experimentation—when I want to distort reality or create more artful, conceptual, and/or abstract imagery.

What's particularly unique about the Iris Photo Suite app is that it allows you to create, manage, and blend multiple images as layers to expand your creative options. For example, you might capture an image of textured concrete and use this image as a base layer for your creation. You can add a second image such as a portrait, and overlay this second image as a layer on top of the base layer of textured concrete. Blending the images, you can specify how much of the base layer you want to reveal below the top layer, your portrait. If you like the look of textured, collaged, layered, more artful, or abstract photographs, Iris Photo Suite offers unlimited creative possibilities. Explore these image experiments to see how you can dramatically alter the reality of your original photographs.

> **Connect Online**
>
> **Iris Photo Suite**—http://ventessa.com/Ventessa/Home.html
> **Image Gallery on Flickr**—http://www.flickr.com/groups/irisphotosuite/
> **Twitter**—VentessaDevFeed

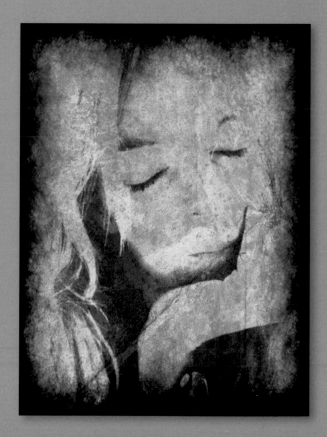

Apply Creative Effects and Blend Two Image Layers

In just eight steps you can dramatically change the look and feel of your photographs using the advanced features of Iris Photo Suite to make adjustments, apply creative effects, and layer and blend two (or more) images to create a new image. Using the Cameramatic app, I used the front-facing camera to shoot the texture of pollen swirls on my concrete driveway, and using the native, back-facing camera, I shot a self-portrait.

IRIS PHOTO SUITE

1 Tap to launch Iris Photo Suite, then tap the filmstrip icon in the lower right corner to select an image from your image library. Choose from processing options above the image. Here, I tapped "Adjustments" and sharpened the image, adjusting the strength of the effect. Tap "Apply" to accept the effect on the image.

2 To further texturize the image, I tapped "Fx" to reveal filter categories, and tapped the "Vintage" set of effects. I tapped the "Reminiscence" effect, and reduced the strength to 61% before applying the filter.

3 Satisfied with the textured image, I tapped "Adjustments" and then "Layers" to set the image as the base layer for my new image.

IRIS PHOTO SUITE

4 Next, I was ready to add the second image as a layer on top of the base image, so I tapped the filmstrip icon to select an image from my image library. I chose a self-portrait previously shot with the native front-facing camera.

5 I then tapped "Fx" and the "Bw Fx" category of filters. I tapped the "History" effect to apply a high-contrast, sepia tone on the image, retained the default effect at 100%, and applied it to the image.

6 I then tapped "Adjustments" and the "Adjustments" option to increase Brightness/Contrast, Saturation, and Temperature on the image. Satisfied with the result, I tapped "Apply."

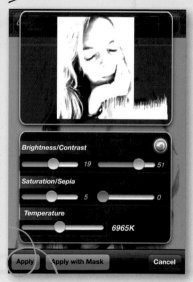

IRIS PHOTO SUITE

Layer Dimensions

Base Layer: 1024x1024
Current Layer: 480x640

Please select the layer whose
dimensions you would like to retain
in the final image.
Iris will automatically resize the
other layer to match the same.

Base Current

Blur Layer

Mosaic Layer

Blend with Base

Set Layer as Base

Cancel

Layer

Opacity 51

Blend Mode: Normal

Done Layer / Base Cancel

Iris Photo Suite

How would you like to apply the
Mask over this action?

Draw Mask

Use the Image Mask

Use Inverted Image Mask

Cancel

7 I wanted to blur this second image as a layer on top of the base image, so I tapped "Adjustments" and "Layers" and then selected "Blend with Base." The base layer was square format and larger than the current layer, so I chose to use the "Current" layer so the app would resize and align the base layer beneath the current layer. Retaining the default "Normal" blend mode, I reduced the "Opacity" to 51% and tapped "Done." Opting to apply the blend to the entire image (vs. specifying a mask), I tapped "Cancel."

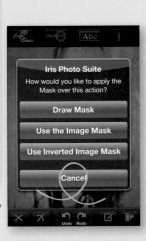

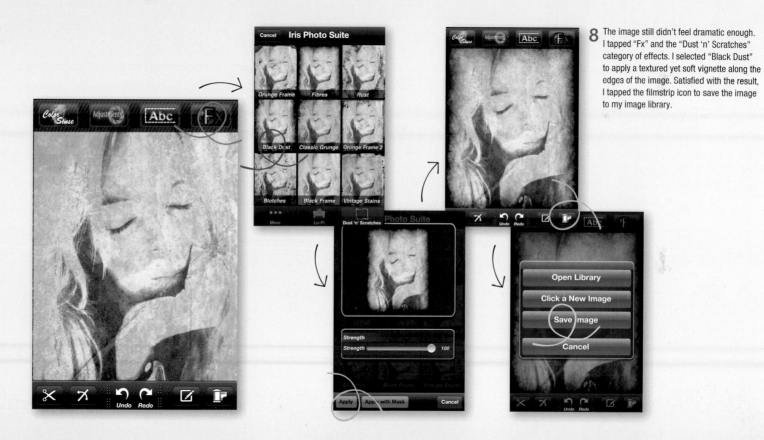

8 The image still didn't feel dramatic enough. I tapped "Fx" and the "Dust 'n' Scratches" category of effects. I selected "Black Dust" to apply a textured yet soft vignette along the edges of the image. Satisfied with the result, I tapped the filmstrip icon to save the image to my image library.

IRIS PHOTO SUITE

Processing an Image Using More than One App

There are times when one app doesn't provide enough control to create the image you see in your mind. As you become proficient with the apps in your toolkit, you'll probably find that you like different features in different apps, depending on the type of image you want to create. For this reason, I might start with an image I shot using the native camera and edit the image using more than one app. In each of these self-portraits, I used the Iris Photo Suite app for initial processing and a second app to create two different visual effects. Keep in mind that apps may or may not save your image at maximum resolution. To find out, check the settings within each app.

Apply an Image Filter with the Lo-Mob App

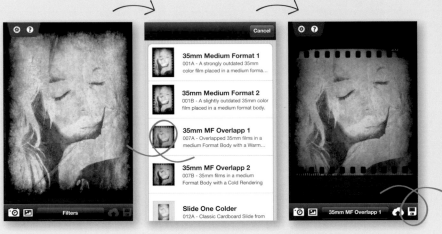

1 I launched the Lo-Mob app and opened the self-portrait in my image library. Lo-Mob instantly generates a thumbnail preview list of the image with effects applied. I tapped the "35mm MF Overlapp 1" option because I liked its retro filmstrip border and square format.

2 Satisfied with the result, I tapped the disk icon in the lower right corner to save the new image to my image library.

Add a Frame with Snapseed

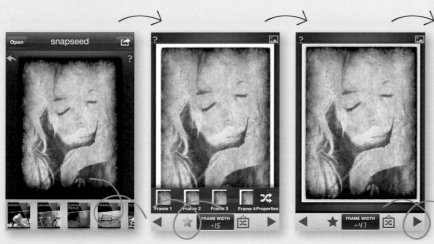

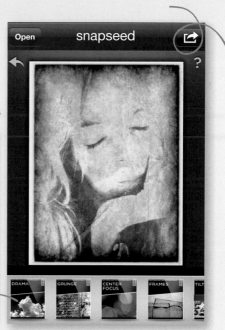

1 I launched Snapseed and opened the image in my image library. To apply a border to the image, I tapped "Frames" and then the star icon to reveal frame options.

2 I tapped "Frame 3," then dragged my finger horizontally over the image to increase and decrease the width of the frame until I was satisfied with the look. I tapped the forward arrow to accept the frame.

3 Next, I saved the image to my image library.

TILTSHIFTFOCUS

The TiltShiftFocus app gives you the ability to simulate shallow depth of field with your images. It lets you single out and focus on a subject within your composition, while at the same time reducing the effect of distracting background clutter by blurring your background to the degree you choose. With TiltShiftFocus, you determine the focus effect that works best for your image.

While the native camera does allow you to select an area of focus by tapping on the element in your composition, TiltShiftFocus gives you greater control and the ability to blur (or add bokeh), simulating the look of a wide-aperture setting (or low f/stop number) you might specify on an SLR camera. Some apps such as Snapseed and Instagram offer tilt and shift functionality, but the TiltShiftFocus app offers more control.

Connect Online

TiltShiftFocus—http://dev-lux.com/tiltshiftfocus/

Original image shot and processed with the Snapseed app.

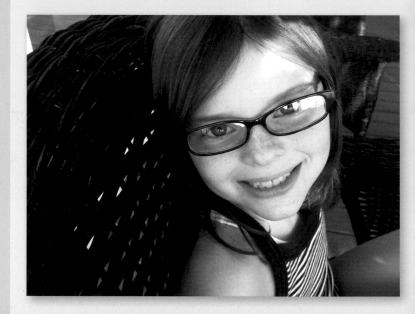

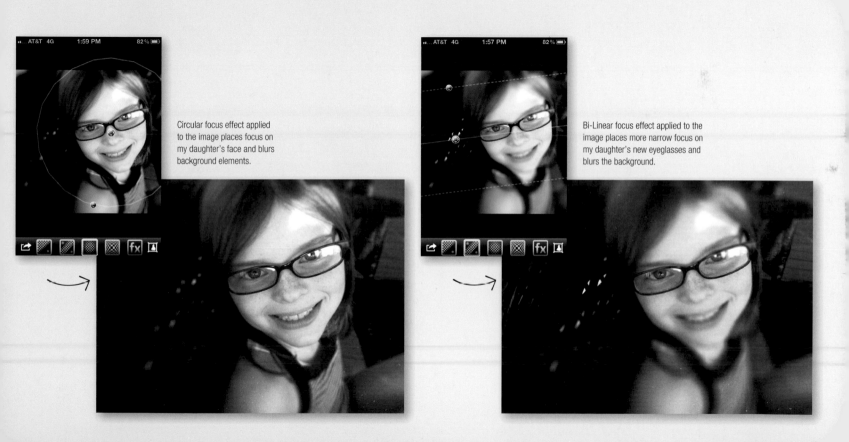

Circular focus effect applied to the image places focus on my daughter's face and blurs background elements.

Bi-Linear focus effect applied to the image places more narrow focus on my daughter's new eyeglasses and blurs the background.

TILTSHIFTFOCUS

Adjust Depth of Field

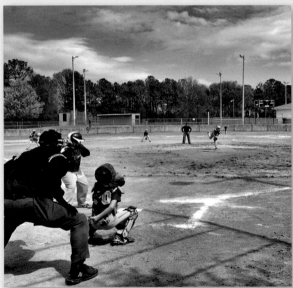

Image shot with the
Cameramatic app
and processed with
Snapseed app.

1 Tap to launch TiltShiftFocus. Tap on the
arrow icon in the lower left corner to
load an existing picture from your
image library, or use the camera to
shoot an image. If you use the camera
to shoot, after you've shot the image, it
will appear in preview mode onscreen.
Tap the "Use" button to display the
image with processing tools.

Default placement of Bi-Linear effect
on image.

Zoom focus effect
manually positioned
on image.

2 Determine where you want to apply
selective focus. In this image, I wanted to
apply a shallow depth of field and simulate
a zoom action by placing the selective
focus on my son's pitch and blurring the
batter, catcher, and umpire. To do this, I
chose the "Zoom" focus effect. I dragged
the center of the circular area and centered
it over the baseball. Then I repositioned the
circular boundary to refine the width of the
area to broaden the area of focus.

3 To further refine the image or your selective area of focus, tap the "Fx" button and adjust controls. When you are satisfied with the image, tap the close icon, then tap the arrow icon in the lower left corner to save the image to your image library.

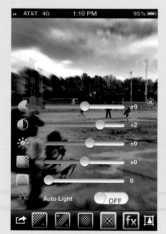

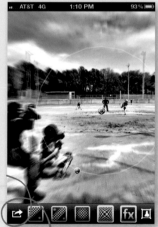

Tilt-Shift-Focus

Load image

Use Camera

Save image

Help

Cancel

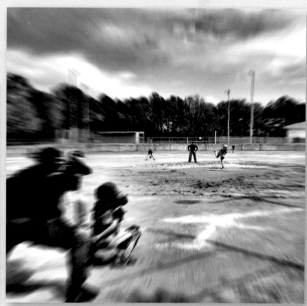

PHOTO FX

The Photo fx app offers a comprehensive set of image filter groups containing more than 850 presets that simulate popular Tiffen glass filters, specialized lenses, optical lab processes, film grain, exacting color correction, natural light, and photographic effects, as well as providing a paint system with a variety of brushes to expand your creative options. Beyond that, each preset offers fine-tuned controls to increase or decrease setting amount(s), giving you complete creative processing control over your image. For example, the Sharpen preset offers slider-bar controls for amount, radius, and threshold to give you full control over Sharpen settings.

Connect Online

Photo fx—www.tiffen.com/photofx_homepage.html
Image Gallery on Flickr—http://www.flickr.com/groups/tiffenphotofx/

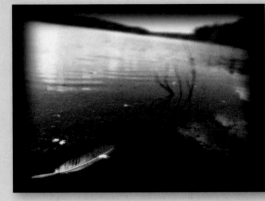

Adjust Color Tint, Haze, and Temperature
Before you get started with Photo fx, first tap on the folder icon (the wrench) on the welcome screen to adjust your image output size. For optimal image quality, set the maximum output size to "Full." If you choose to shoot images within Photo fx and you want to save the original image before you begin adding one or more effect layers, set this option to "ON." It's a good idea to save your original image in the event you want to process it in another way.

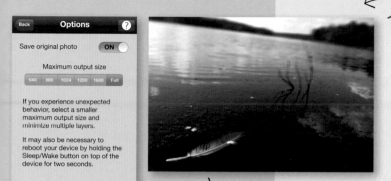

Options

Back **Options** ?

Save original photo **ON**

Maximum output size

640 800 1024 1280 1600 Full

If you experience unexpected behavior, select a smaller maximum output size and minimize multiple layers.

It may also be necessary to reboot your device by holding the Sleep/Wake button on top of the device for two seconds.

You can export and share images at lower resolution to reduce image file size. You can also add credentials for your Twitter, Picasa, Facebook, and Flickr accounts to make it easy to export and upload images from Photo fx to those online destinations.

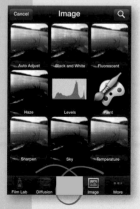

Cancel **Image**

Auto Adjust Black and White Fluorescent

Haze Levels Paint

Sharpen Sky Temperature

Film Lab Diffusion Image More

1 Tap to launch Photo fx. It will default open to the welcome screen. Tap on the folder icon to select and open an existing image from your iPhone image library, or the camera icon to shoot an image. Photo fx generates a collection of thumbnail preview images representing presets organized by filter groups. I tapped the Grads/Tints filter group on the bottom menu to view its preset options.

2 On the Grads/Tints screen, tap the preset you want to use. In this example, I chose Nude/FX®. This preset offers six options on a secondary screen. I chose Nude/FX® 1. To reduce the tint amount, drag the slider bar to the left. To increase the tint amount, drag the slider to the right. When you are happy with the effect on your image, tap the save button in the lower right corner and select "Add Layer" if you want to continue editing your image, or select "Save" if you are finished editing your image.

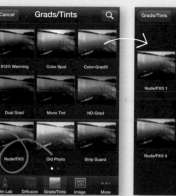

Cancel **Grads/Tints**

812® Warming Color Spot Color-Grad®

Dual Grad Mono Tint ND-Grad

Nude/FX® Old Photo Strip Guard

Film Lab Diffusion Grads/Tints Image More

Grads/Tints **Nude/FX®**

Nude/FX® 1 Nude/FX® 2 Nude/FX® 3

Nude/FX® 4 Nude/FX® 5 Nude/FX® 6

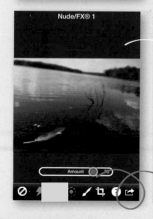

Nude/FX® 1

Amount

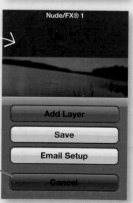

Nude/FX® 1

Add Layer

Save

Email Setup

Cancel

PHOTO FX

3 Let's continue to edit the image and choose another effect. To back out of a preset screen and return to the main filter screen, tap on the previous button in the upper left corner. When you return to the filter screen, you can change filter groups by tapping on the bottom menu items. In this example, I returned to the Image filter and selected the "Haze" preset. On the Haze secondary screen, I chose "Haze 1" and adjusted the amount of Haze and Temperature.

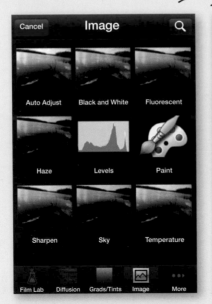

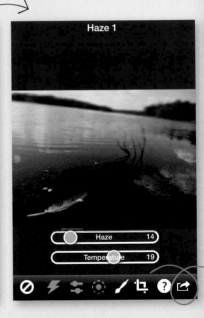

4 To finish and save your image, tap on the save button in the lower right corner and select "Save." The image will be accessible from your image library.

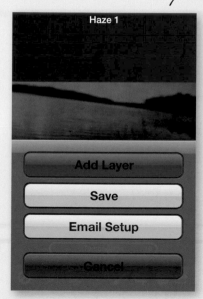

Haze 1

Add Layer

Save

Email Setup

Cancel

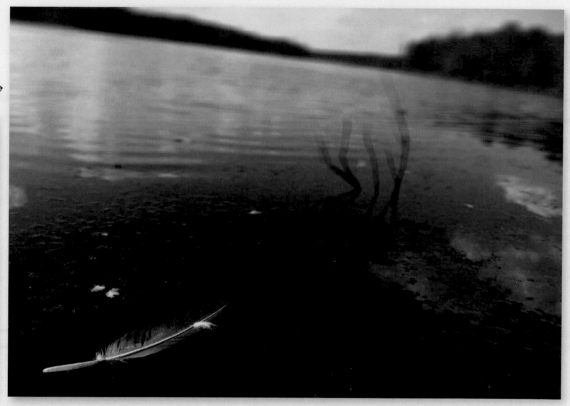

PHOTO FX

Example Photo fx Effects

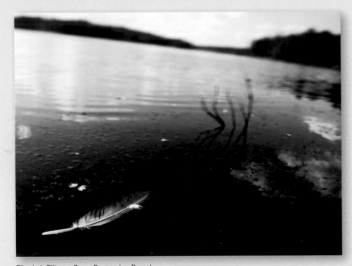

Film Lab Filter > Cross Processing Preset

Film Lab Filter > Bleach Bypass Preset

Diffusion Filter > Cool Pro-Mist® Preset

Diffusion Filter > Bronze Glimmer Glass Preset

Grads/Tints Filter > Strip Grad Preset > Cool Blue

Grads/Tints Filter > Old Photo Preset > Silver Gelatin

Grads/Tints Filter > Color-Grad® Preset > Coral

Light Filter > Warm Preset

Light Filter > Edge Glow Preset

Special fx Filter > Fluorescent Preset

Special Filter > Antique Preset

Special Filter > Day for Night Preset

HIPSTAMATIC

Hipstamatic was designed to mimic the unique style of vintage prints characterized by vignettes, blurring, textured edges, and over-saturated colors, created with the original analog Hipstamatic 100 plastic camera launched in 1982. The app gives you the ability to switch lenses, flash, and "film" with the swipe of a finger to customize a digital HipstaPrint *before you shoot* through the square-format viewfinder. Each film option creates a square-shaped image with a unique border. The app comes with a standard selection of lenses, film, and flash, with the option to purchase additional supplies (or Hipstapaks) to expand your creative resources.

Connect Online

Hipstamatic—http://hipstamaticapp.com/
Image Gallery on Flickr—http://www.flickr.com/groups/hipstamatic/
Twitter—hipstamatic

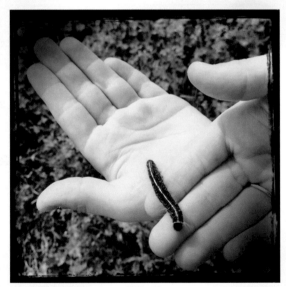

MAR 82

How to Make and Share a HipstaPrint

Before you get started with Hipstamatic, first go to the Settings app on your iPhone and select the Hipstamatic app to adjust settings for viewfinder mode, auto-save, and date and artist credit preferences to appear on your images.

1 Tap to launch Hipstamatic. On the camera front view, swipe the handle of the lens to specify image quality (high, medium, or low). While low- and medium-quality images are smaller in size and require less time to process, high-quality images give you maximum flexibility for printing and enlargement.

2 Next, select your film, lens, and flash settings. Tap the film icon and swipe your finger vertically through the list of options. Tap the film cartridge to view a description and sample of the film output. Tap "Done" to select the film.

3 Swipe horizontally across the current lens to view lens options. Tap the lens to view a description and sample of the lens output. Tap the flash icon and swipe horizontally through options, then tap "Done" to select the flash.

HIPSTAMATIC

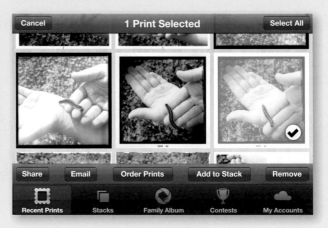

4 When you're ready to shoot, tap the arrow icon to flip to the camera back. Hold the camera horizontally and frame your subject within the square-format viewfinder. The default setting for flash is "off," however, you can turn it "on" by sliding the flash switch to a low or high flash setting when you choose. Tap the yellow shutter button to shoot. If you are developing high-quality prints, note that an image requires several seconds to "process" and "print" within the app before it will be viewable.

5 When the "Print Ready" light illuminates to green, tap on the image icon to view "Recent Prints." Your image will appear as a thumbnail within your archive in chronological order.

Helga Viking Lens, BlacKeys B+W Film, No Flash

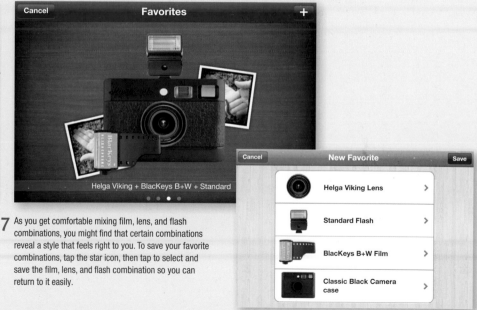

Helga Viking + BlacKeys B+W + Standard

6 Tap an image to enlarge it, and tap it again to reveal lens, film, and flash settings. From here, you can view image information; tag and share the image in one or more of your social networks, including Instagram, Facebook, Twitter and Flickr; delete it; or order a print from the HipstaMart Print Lab.

7 As you get comfortable mixing film, lens, and flash combinations, you might find that certain combinations reveal a style that feels right to you. To save your favorite combinations, tap the star icon, then tap to select and save the film, lens, and flash combination so you can return to it easily.

HIPSTAMATIC

Hipstamatic Film Options

You can shoot with a variety of film options in the Hipstamatic app to achieve different image results.

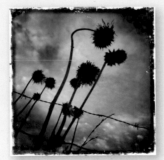

Kokot Verichrome film, John S lens

Ina's 1969 film, John S lens

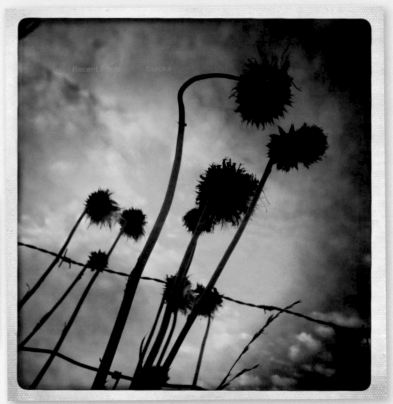

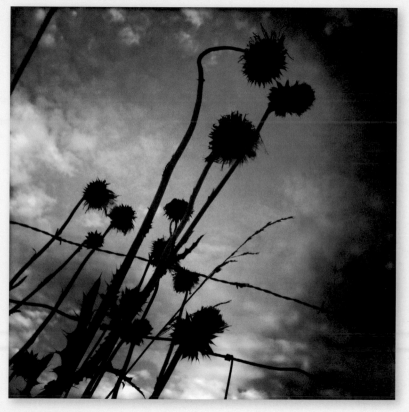

Alfred Infrared film, John S lens

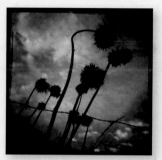

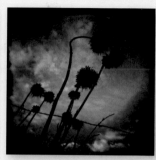

BlacKeys B+W film, John S lens

BlacKeys SuperGrain film, John S lens

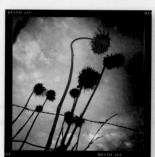

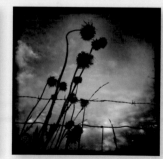

Pistil film, John S lens

Float film, John S lens

HIPSTAMATIC

Try Making a Processing Decision Before You Shoot
Unlike the traditional approach to digital photography, where most image processing occurs after you've captured the image, shooting with the Hipstamatic app forces you to make processing decisions such as film and lens selections before you shoot. At times, I like shooting with Hipstamatic because of this constraint and the fun serendipity of the results. It challenges me to quickly assess my shooting scenario and take a risk. It reminds me of the days when I had to make the choice of what film speed to load in my camera, or to decide upfront if I wanted to shoot in color or black and white.

Shooting with Hipstamatic also gives you the ability to create a series of images in a consistent style as you shoot. During a trip to Nepal, I wanted to focus on seeing and shooting, and to quickly publish and share images in my online journal and with my Twitter followers. I chose to shoot the entire experience using Hipstamatic with one film choice (Ina's 1969) and one lens choice (John S) to visually connect the images.

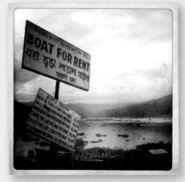

Consider Your Intent: Speed vs. Flexibility

When I made these images (right) in east Atlanta, I was feeling nostalgic. I had driven past this vacant building for years on my way to and from work, but let the creative impulse to shoot it pass each time. When I found myself in this space with my iPhone in hand, nearly two years later, with just a few moments to spare, I chose to shoot with the Hipstamatic app to minimize choices and time with image processing. This meant I could quickly publish and share the images in my online journal to mark the moment in time.

Shot with Hipstamatic: John S lens, Pistil film, flash off.

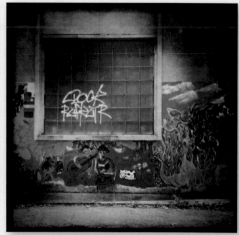

Shot with Hipstamatic: John S lens, Black Keys SuperGrain film, flash off.

LO-MOB

Lo-Mob gives you a wide range of creative analog photography-style filters to apply to your images. Each predefined filter varies in image crop and format, color, texture, and border to apply a unique vintage look to your image. You can shoot an image using the native camera, and select and open it to process within Lo-Mob, or you can shoot from within the Lo-Mob app. Lo-Mob retains the original source image in the image library, so you can process it multiple times and in multiple ways.

Beyond the variety of creative effects, what I like about Lo-Mob is its simplicity. You can easily open an image, and within just a few seconds, Lo-Mob generates a preview list showing a thumbnail version of your image with each of the variants applied to it. This feature makes it quick and easy for you to scroll through the creative effects by category (Classic Vintage, 35mm Film Experimentation, Through the Viewfinder, Emulsions, Instant Matic Photography, and Contact Mask Postcards) and tap to make your processing selection. Once you've previewed the larger-size image, you can save and easily share it via email, Facebook, Twitter, Picasa, or Flickr.

Attracted by the simple circular shape of barbed wire on a farm fence, I quickly shot this image on an overcast day and processed it with Lo-Mob in a variety of ways. As ths shows, there's more than one way to "see" an image.

Connect Online

Lo-Mob—http://lo-mob.com/
Image Gallery on Flickr—http://www.flickr.com/groups/1304825@N22/
Twitter—lomobcom

Example Lo-Mob Vintage Effects

Lo-Mob offers a variety of retro filters to enhance the look and feel of your original image. Refer to the Lo-Mob app help screen for detailed instruction on advanced filter editing.

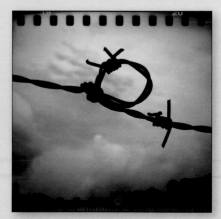

Vintage Effect: 35mm MF Overlapp 1

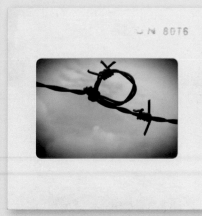

Vintage Effect: Slide One Colder

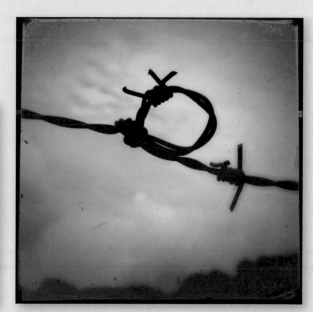

Vintage Effect: 6 x 6 TTV Green Virage

LO-MOB

Example Lo-Mob Vintage Effects

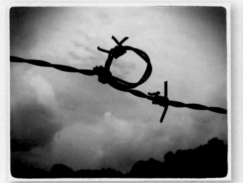

Vintage Effect: Photocard Three

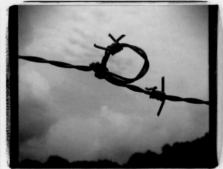

Vintage Effect: News Emulsion

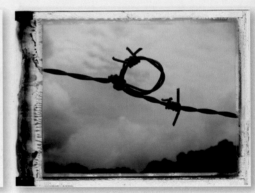

Vintage Effect: 6 x 9 Instant Emulsion

How to Apply a Vintage Effect

Before you get started with Lo-Mob, first tap on the gear icon on the welcome screen to adjust Settings for effects and picture resolution. For optimal image quality, set the app to "Save" at "Maximum" resolution. You can export and share images at lower resolution to reduce image file size. You can also add credentials for your Twitter, Picasa, Facebook, and Flickr accounts to make it easy to export and upload images from Lo-Mob to those online destinations.

1 Tap to launch Lo-Mob. Tap on the camera icon to shoot an image, or tap on the image icon to select and open an existing image from your iPhone image library. Lo-Mob will instantly generate a thumbnail preview list of your image with effects applied.

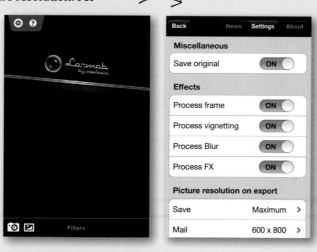

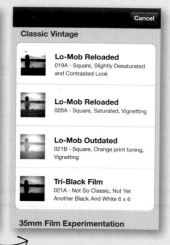

LO-MOB

2 In the image preview list, filters are categorized: Classic Vintage, 35mm Film Experimentation, Through the Viewfinder, Emulsions, Instant Matic Photography, and Contact Mask Postcards. Swipe your finger up and down to scroll through the list of options and tap on a filter preview to view a larger version of the filtered image.

3 If you are satisfied with the image, but wish to make advanced edits, tap the filtered image and choose from available options below. For example, you can turn the filter on or off but retain the frame, or vice versa. Tap the reload icon to accept the filter adjustment.

4 If you are satisfied with the image as is, tap on the disk icon in the lower right corner to save it to your image library, copy it in the clipboard, print it, or open the image in another app such as Instagram for further editing and sharing.

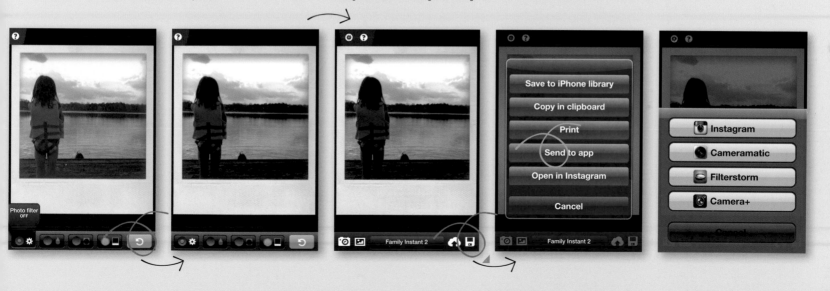

EXPLORE MORE APPS

Photoshop Express

Use Photoshop Express with its add-on Camera Pack to reduce noise and smooth out image grain, or use the camera timer to shoot self-portraits or eliminate camera shake when your iPhone is attached is to a tripod or kickstand. The app offers quick and simple image-editing features for cropping, flipping, sharpening, and straightening photos, and allows you to make basic adjustments to exposure, contrast, tint, and saturation. The add-on Border Pack offers a wide variety of border options.

Photoshop Express—www.photoshop.com

Perfectly Clear

Use Perfectly Clear to sharpen your images and tighten control over exposure, contrast, color vibrancy, and tint. You can see your original image shot with the native iPhone camera compared to the Perfectly Clear image side-by-side within the app before further refining and saving the "corrected" image. This app is particularly useful for improving clarity and sharpness of images shot with an older iPhone.

Perfectly Clear—www.athentech.com/iPhone.html

ShakeItPhoto

Use ShakeItPhoto to apply a Polaroid-esque instant style to your image. Open an existing image from your library or shoot with the app and shake it to apply this easy process. ShakeItPhoto dynamically crops your image to a square format and adds a lightly textured off-white border around.

ShakeItPhoto—www.shakeitphoto.com/
Image Gallery on Flickr—www.flickr.com/groups/1077237@N20/pool/
Twitter—ShakeItPhoto

Camera Awesome by SmugMug

Use Camera Awesome as a replacement for the native camera (both still and video) on your iPhone for nifty shooting features like composition guidelines, image stabilization, big-button functionality (so you can tap anywhere on your iPhone screen to trigger the shutter), a timer, and fast- and slow-burst shooting. You can quickly "awesomize" your image or choose from a variety of features to transform image dimensions, and apply limited preset effects, filters, textures, and frames (with an option to purchase more). Image information conveniently reveals the size of your image and the date it was taken.

Camera Awesome—www.awesomize.com/
Image Gallery on Flickr—www.flickr.com/groups/camera_awesome/
Twitter—SmugMug

Cameramatic

Use Cameramatic for high-resolution square-format shooting and a variety of comprehensive image-processing capabilities. You can quickly apply standard, color, Xpro, black and white, or custom filters you create on your images and add a frame from a vast collection of standard, film, TTV, and texture categories. Additional settings let you create light-leak effects, vignettes and film simulation to add grain to your black-and-white images. If you like Hipstamatic, but crave the ability to process clean, square-format images after you shoot, you'll love Cameramatic.

Cameramatic—www.mudaimemo.com/iphone/cameramatic/
Image Gallery on Flickr—www.flickr.com/groups/cameramatic/

Instagram

Use Instagram, owned by Facebook, for basic photo editing and/or to share your iPhoneography within its popular social network of more than 100 million mobile photographers and photo enthusiasts. Instagram users can share, browse, view, and exchange feedback (likes and comments, including keyword hashtags) on photographs published in chronological order by users within the online community. It's easy to find and follow your existing friends and contacts from Facebook and Twitter, and to discover the work of new photographers by following the "likes" and "comments" made by the users you follow. If you choose Instagram to be your initial image-publishing destination, you can adjust settings for the app to auto-publish the image to all of your social networks and destinations including Posterous, Tumblr, Facebook, Flickr, Twitter, and others.

Instagram—www.instagram/
Twitter—instagram

EXPLORE MORE APPS

Filterstorm

Use Filterstorm for more advanced, professional-level image processing and management features to set custom canvas sizes, image scaling, and straightening; flexible filters for exposure, brightness and contrast, curves, shadows and highlights, white balance, noise reduction, tone mapping, red-eye removal, and cloning. You can set up layers and edit masks; apply watermarks to embed a copyright or brand on your images; and manage EXIF and IPTC data to capture and connect location details, captions, keywords, contact information, and more.

Filterstorm—http://filterstorm.com/
Image Gallery on Flickr—http://www.flickr.com/groups/1699242@N20/
Twitter—filterstorm

Diptic

Use Diptic to connect and format two or more images into a single image to portray a sequence of events, a before-and-after contrast, or a visual story using a variety of flexible layouts. Layouts are comprised of flexible grids so you can create a simple diptych or triptych or a more complex multi-image mosaic. Select images from your image library, Facebook or Flickr photo galleries and crop, zoom, or adjust individual image effects such as exposure, contrast, and color saturation. You can also minimize or customize the look of image borders.

Diptic—http://www.dipticapp.com/
Image Gallery on Flickr—http://www.flickr.com/groups/diptic/
Twitter—diptic

MoPho

Use MoPho to create and order prints (on paper, canvas, ceramic tile, easel-backed panels, or aluminum) and photo-based products such as iPhone or iPad cases, mugs, keychains, washable tattoos, keepsake boxes, coasters, water bottles, mousepads, canvas totes, t-shirts, and more using your iPhone images. Be sure to save your images at the highest-quality resolution to enable the broadest level of product creation flexibility.

MoPho—http://mophoapp.com/
Twitter—mopho
Instagram—mophoapp

Keep Your Apps Up to Date

App creators provide updates to their apps regularly to fix bugs, enhance existing features, and add new capabilities. It's important to update your apps to ensure that they function properly with the latest version of your iPhone operating system (iOS). To find out if any of your apps have updates available, look at the App Store icon on your iPhone and follow these steps in the presence of a mobile data or wifi connection:

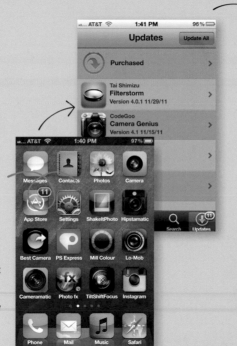

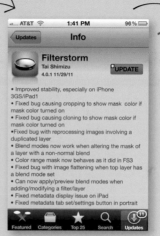

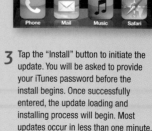

1 If you see a small number on your App Store icon, tap the icon to display a list of updates available for download.

2 Tap the app to review information about the update. Most updates are free, but if there is a cost associated with the update, it will be displayed on this screen.

3 Tap the "Install" button to initiate the update. You will be asked to provide your iTunes password before the install begins. Once successfully entered, the update loading and installing process will begin. Most updates occur in less than one minute.

SPARK YOUR CREATIVITY

If I asked you and a group of fellow iPhoneographers to shoot the same subject, undoubtedly no two images would be alike. You might step back and offer a wide-angle view, to convey a story. You might creep in close and study the texture, offering an imaginative abstraction of your subject. Or you might slip into the shadow of your subject and expose a flaw we might not have otherwise seen. But what attracts your eye? What drives your perspective? What makes your photographs unique to you?

Think of iPhoneography as a method of creative discovery—a daily practice to help you uncover your vision as a photographer. Whether you realize it or not, your vision has been building since you were born, and it's unique to you. It's the sum of your past experiences and what you are seeing, feeling, and thinking in the present moment. Your vision defines your unique view of reality and will be expressed subconsciously in the images you make. The best way to uncover your vision is to shoot frequently, study your images, and look for trends.

Grant yourself five minutes each day to play the role of life explorer. Think of your iPhone as a magic device to collect visuals that attract your eye, intrigue your mind, or stir your soul. Train your eye to get in the habit of studying the light, shapes, patterns, textures, and colors defining the space that surrounds you, and reach for your iPhone to make an image when you see something that strikes you. It might be the bold profile of a mountain or an airplane, the pattern of electrical wires over your head, the texture of broken brick, or your own reflection in the curve of a spoon. There's no need to take your iPhone images too seriously. In fact, it's best if you don't. Let your iPhone images be loose and experimental.

Collect your visual discoveries by publishing your iPhone images online so you can follow and analyze the evolution of your vision over time. (For more on this, turn to Chapter 6, "Join the Community.") Think of it as tracing the progression of marks in a sketchbook, or following the path of words and phrases as they form stories or poems in a journal. Over time, patterns will emerge and you'll begin to define your vision not simply by the subject matter you choose to shoot, but by the way in which you choose to see it.

Accept a Secret Mission

There are endless sources of visual inspiration within walking distance of your home, school, office, or local grocery store. But if you need a little creative inspiration to stretch your view, accept one or more of the secret missions listed in this chapter and share your discoveries with us.

Connect Online

Title each of your images with the name of the secret mission and join our Flickr group to share them here:
Flickr—http://www.flickr.com/groups/iphoneographyart/

SPARK YOUR CREATIVITY

1. Be silent in a cemetery.
2. Visit a farm and explore a worn path.
3. Make a cup of tea and follow the color saturation of water.
4. Document an abstract reflection in a puddle of water.
5. Find something blue.
6. Pay attention to words and phrases painted on buildings.
7. Seek out light in the dark.

1

2

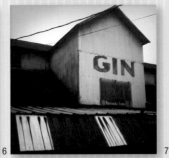

3

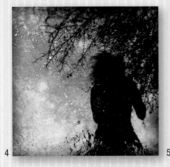

4

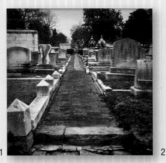

5

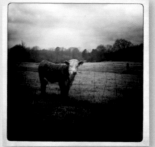

6

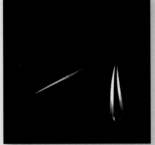

7

8. Put yourself in an urban setting and follow the flow of graffiti or other bold forms of public expression. Crop phrases to select words or shapes that stir you.
9. Look for odd combinations of elements.
10. Tour a city in the dim of night.
11. Minimize the horizon.
12. Sink back into bed and notice the creases and familiar folds of pillows and sheets.
13. Hard boil, crack, and peel some eggs. Pile up the delicate shells.

8

9

10

11

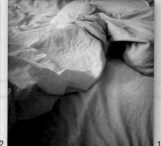

12

13

14. Seek out a repetitive pattern.
15. Find jagged edges or points of intersection.
16. Watch something disappear.
17. Find your image in a shiny metal surface.
18. Attend a behind-the-scenes tour of the zoo and befriend a zoologist.

15

16

14

17

18

19. Throw something or someone in water and evaluate the splash.
20. Let raindrops distort your view through the window.
21. Ask someone to make a wish.
22. Submerge yourself and shoot just above the water level in a pool full of people.
23. Grant yourself permission to make an honest self-portrait on a weekly basis.
24. Go someplace you've never been.

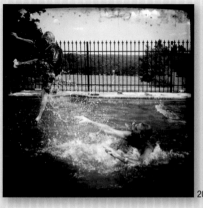

19

20

21

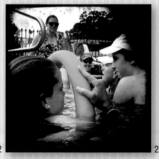

22

23

24

SPARK YOUR CREATIVITY

25. Create abstract compositions of
 electrical wires on a backdrop of sky.
26. Find a disconnect.
27. Climb to the top of a flight of stairs
 and look down.

25

26

27

28. Discover unrelated objects in a shared space.
29. Ride a train and study strangers as they enter and exit.
30. Segment a space into three unequal sections.
31. Seek out geometric shapes in shades of gray.
32. Let the dishes pile up in the sink and extract compositions.
33. Submerge something tall in a glass half-full of water.
34. Put yourself on a horizontal plane and shoot what appears closest to you.
35. Shoot your shadow on a textured surface.

28

29

30

31

32

33

34

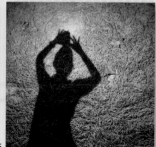
35

SPARK YOUR CREATIVITY

36. Find two unrelated objects with similar shapes.
37. Experience a scene through a screen or faded glass.
38. Let the weeds get a little out of control.
39. Exploit a variety of textures in a single scene.
40. Admire the color palette of butterfly wings.
41. Simplify something to the point of abstraction.
42. Record words and phrases that speak to you in public places.
43. Take notice of people or objects aligned with lines on the ground.
44. Find one color to connect two objects in a tight space.
45. Craft an unrealistic environment.
46. Call out to your pet and record the moment of connection.
47. Stand at a bus stop. Notice what people do when they wait.
48. Stop to take a peek inside an open window.

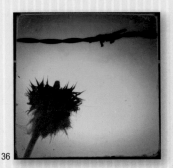

36

37

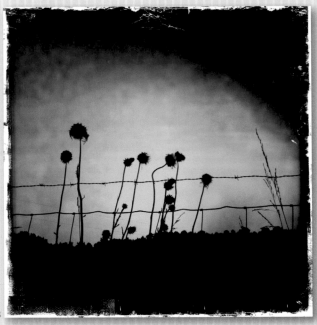

38

SPARK YOUR CREATIVITY

49. Place something small beside something really tall.
50. Visit a friend and survey the objects in the neighbor's backyard.
51. Be still with someone you love as they sleep in morning light.
52. Invite a critter into your hand.
53. Learn to embrace the blur of motion.
54. Make water stains.

49

50

51

52

53

54

55. Shoot someone shooting.
56. Watch the body language of best friends.
57. Minimize the view of a seemingly complex scene.
58. Explore a science museum and note the visuals that make you pause.
59. Juxtapose something old and something new.
60. Peel an orange. Study the segments.

55

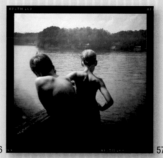

56

57

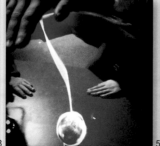

58

59

60

SPARK YOUR CREATIVITY

61. Choose the window seat.
62. Find something old and faded.
63. Offer a fresh view of a familiar statue
 or monument.
64. Ask someone to make a big leap.
65. Put something delicate on concrete.
66. Tilt a horizontal scene on a diagonal.

61

62

63

64

65

66

67. Meet an imaginary friend.
68. Capture the opposite of a smile.
69. Notice the impact of advertisements in a landscape or cityscape.
70. Find something in a state of rest.
71. Document a curious moment from an inconsequential sequence of events.
72. Notice unfamiliar marks in a foreign place.

67

68

69

70

71

72

SPARK YOUR CREATIVITY

73. Sneak in a kiss.
74. Seek color.
75. Hand someone something.
76. Follow a crowd of people
 with umbrellas.
77. Eavesdrop on a conversation, but
 focus on the facial expressions.
78. Watch an event and capture it
 through the fence.

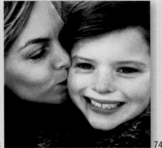

73

74

75

76

77

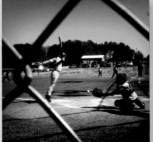

78

79

80

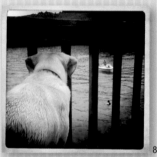

81

82

83

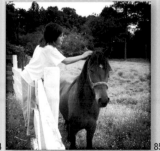

84

85

79. Study the texture of natural objects found at the beach.
80. Connect objects and exploit the negative space.
81. Share a story from an unusual perspective.
82. Find an inconsistency.
83. Contrast outside with inside.
84. Focus on points of connection.
85. Enlarge something small.

SPARK YOUR CREATIVITY

86. Disrupt a scene.
87. Insert some space.
88. Place unfamiliar objects in hands'
 reach of kids.
89. Find something round.
90. Capture an odd façade.
91. Stay close to a dreamer weary
 from travel.
92. Find an object that disrupts a pattern.

86

87

88

89

90

91

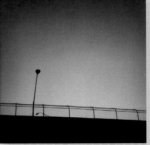

92

93. Study the color and shape
 of your breakfast.
94. Watch someone doing something
 they love.
95. Find someone folded.
96. Find someone folding.
97. Position yourself above
 your subject.
98. Position yourself below
 your subject.
99. Reveal what's hidden.
100. Position yourself as close to
 your subject as you can get.

93

94

95

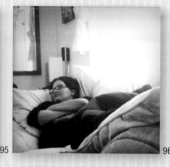

96

97

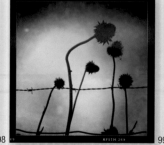

98

99

100

SHOOT HOW YOU FEEL

Whether you consider yourself a photographer, an artist, or simply a curious person fascinated by life, if you're holding this book, I assume you're intrigued with photography as a form of creative expression. In this chapter, we'll loosen up your literal association with imagery and challenge your mind to see beyond the physicality of your subject and to explore a more expressive and conceptual approach to photography.

Keeping your iPhone with you at all times gives you an opportunity to quickly make images to express who you are, what you're thinking, or how you're feeling as you move through the day. Think of iPhoneography as visual journaling. Notice what attracts your eye as your mood shifts. Consider how you might express what's on your mind or in your heart, using life as your canvas. Scan your image library and see what it might reveal about the rhythm of your emotions over time. iPhoneography can help you document not only the moments around you, but the evolution of what's going on inside of you.

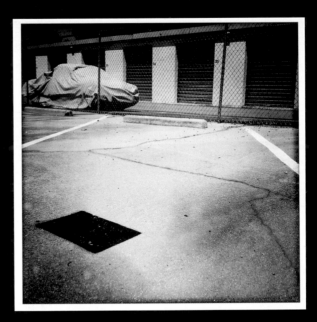

Beyond the simplicity of subject-matter selection, consider ways you can use composition, perspective, light, color, and texture to express yourself. If you're feeling lighthearted and hopeful, you might subconsciously be driven to create images that exude light, and contain broad areas of open space and natural objects with soft, delicate edges. If you're feeling the weight of conflict or loss, your images might reveal dark shadows, complex shapes, jagged edges, or gritty, textured surfaces. You may not consciously understand how your current state influences the images you make, but shooting daily with your iPhone, collecting your images in an online journal, and taking a moment to associate a word or phrase with each of your images will help strengthen your emotional connection to your images.

SHOOT HOW YOU FEEL

Try This:

Scan through your image library and select a handful of your favorites. Study each image and ask yourself these questions:

- What were you doing moments before you made the image?
- What inspired you to make the image?
- How did you feel at that moment?
- How did the time of day, season, or weather impact the moment?
- How does the image make you feel now?
- If you could return to the scene now, how might you see it differently?

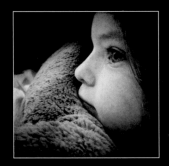

Try This:

Create a series of self-portraits at least once a month for a year. You can also join one of the many online self-portrait groups in Flickr to share your images with a community of contributors (and see how others express themselves). When taking self-portraits, be creative with your environment and the parameters of your crop, and process the image in a way that reflects your current mood. Remember, self-portraits don't have to reveal your face to say something about you. To capture a self-portrait:

- Position yourself in front of any mirror or reflective surface, and hold the phone up to it to make your image. Using an app such as Camera Genius offers a big-button feature that converts your entire viewfinder into the shutter button, making it easy to shoot without click precision.

- Position your iPhone on a mini tripod, kickstand, or the iPole by FastCap and use an app with a self-timer feature such as Camera Genius or Photoshop Express or an app with a sound shutter feature such as CameraSharp for a click-free shutter release.

- Switch to the front-facing camera using the native camera app, compose your shot in the viewfinder, and tap the shutter button.

SHOOT HOW YOU FEEL

Practice

Let's loosen up your literal association with imagery and train your eye to see more conceptually. One way to do this is by associating different words with an image to see how the connection between the two might change the way you feel about an image. Take a look at the following iPhone images and think about the three words associated with each image. Circle the word that resonates with you at this moment or fill in your own words that come to mind when you study the image. Set a date on your calendar one year from today to re-evaluate the images and your word selections to see if you feel differently.

Try a similar exercise with your own photos. Choose and assign a one-word title for images in your online journal, then revisit the photos at a later date to see if you feel compelled to rename them. The life experiences you collect over time will likely reveal shifts in your perspective.

Seek	Accept	Escape
_____	_____	_____

Patient	Eager	Forgotten
_____	_____	_____

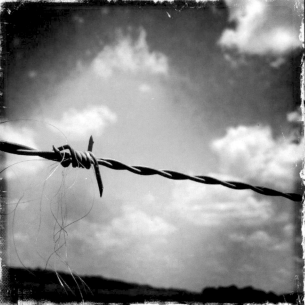

Prepared	Abundant	Predictable
_____	_____	_____

Delicate	Secure	Constrained
_____	_____	_____

Rushed	Solved	Stuck
_____	_____	_____

Uneven	Naked	Perplexed
_____	_____	_____

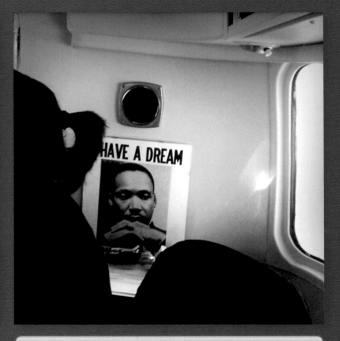

Calculable | Essential | Hopeful

_____ | _____ | _____

Forgotten | Potential | Relevant

_____ | _____ | _____

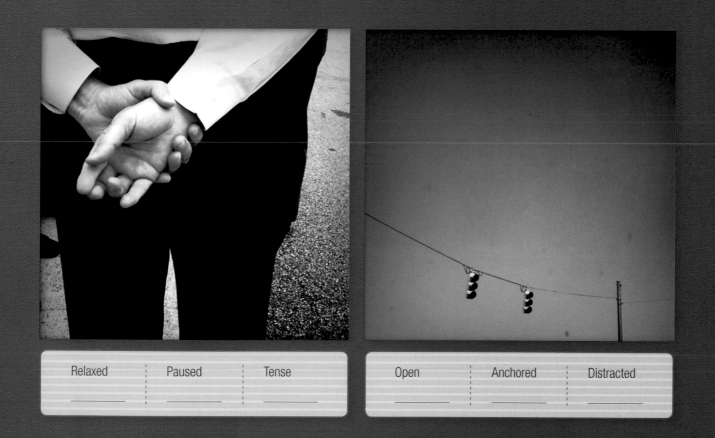

Relaxed | Paused | Tense

_____ | _____ | _____

Open | Anchored | Distracted

_____ | _____ | _____

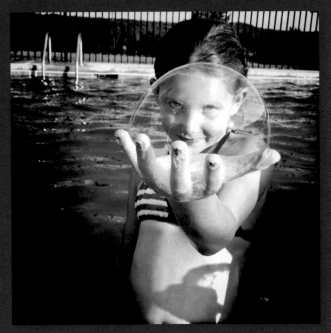

Confident │ Curious │ Fragile

_____ │ _____ │ _____

Precarious │ Pliable │ Infallible

_____ │ _____ │ _____

Hushed	Inspired	Restored
_____	_____	_____

Obstructed	Exposed	Safe
_____	_____	_____

Found | Forgotten | Fixed
_____ | _____ | _____

Fixed | Forgotten | Found
_____ | _____ | _____

Bold	Isolated	Ephemeral	Lured	Transient	Solitary
_____	_____	_____	_____	_____	_____

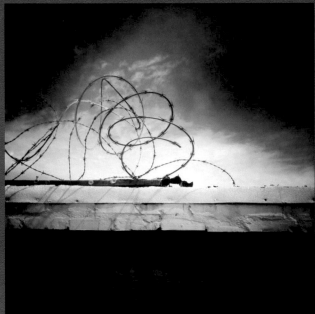

Defaced	Enhanced	Evolved
_____	_____	_____

Deter	Attract	Confuse
_____	_____	_____

Distracted Curious Distant

Broken Revealed Vulnerable

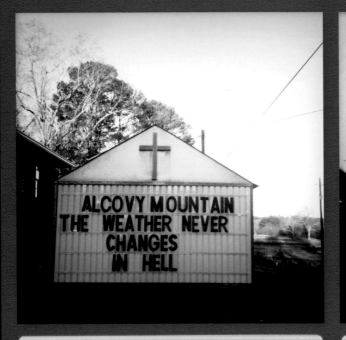

Humorous	Curious	Unsettling
_____	_____	_____

Obscure	Uneven	Permeable
_____	_____	_____

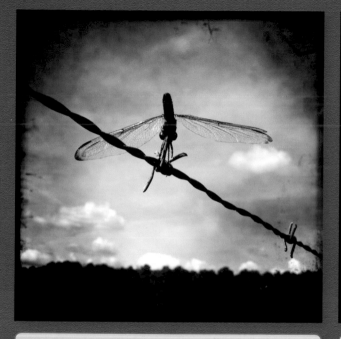

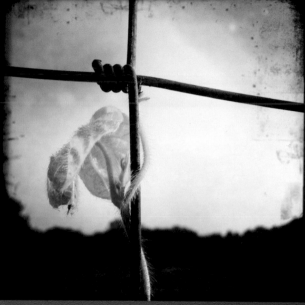

Persistent	Exposed	Grounded
_____	_____	_____

Tentative	Secure	Alluring
_____	_____	_____

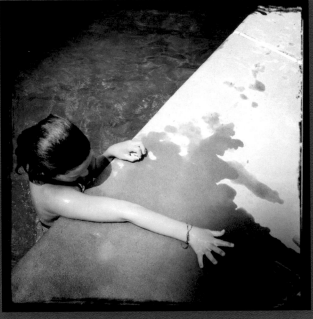

Grateful	Comforted	Wishful
_____	_____	_____

Anxious	Overextended	Lost
_____	_____	_____

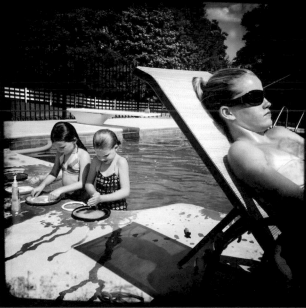

Conflict	Conform	Exclude		Engaged	Ignored	Oblivious
_____	_____	_____		_____	_____	_____

Content | Lazy | Grateful

_____ | _____ | _____

Lonely | Chilly | Secure

_____ | _____ | _____

| Curious | Concerned | Intimidated |
| Crowded | Prosperous | Confined |

EXPERIMENT AND SHARE

Now, choose one or more of these 100 words that best aligns with your current state of mind each week for one year, and use your iPhone to shoot how you feel. Check the word(s) that resonates with you and/or write in the date(s) you chose to shoot how you felt. Title each of your images with the chosen word and join our Flickr group to share your images here: http://www.flickr.com/groups/iphoneographyart/

Connect Online

Flickr—http://www.flickr.com/groups/iphoneographyart/

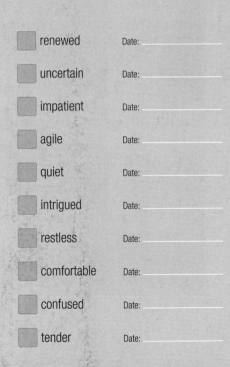

☐ renewed Date: _____

☐ uncertain Date: _____

☐ impatient Date: _____

☐ agile Date: _____

☐ quiet Date: _____

☐ intrigued Date: _____

☐ restless Date: _____

☐ comfortable Date: _____

☐ confused Date: _____

☐ tender Date: _____

broken	Date: _____	tense	Date: _____	healed	Date: _____
passionate	Date: _____	lonely	Date: _____	patient	Date: _____
open	Date: _____	absorbed	Date: _____	connected	Date: _____
free	Date: _____	determined	Date: _____	disconnected	Date: _____
constricted	Date: _____	closed	Date: _____	reflective	Date: _____
stationary	Date: _____	raw	Date: _____	eager	Date: _____
sensuous	Date: _____	daring	Date: _____	searching	Date: _____
enthusiastic	Date: _____	challenged	Date: _____	unclear	Date: _____
creative	Date: _____	bleak	Date: _____	even	Date: _____
relieved	Date: _____	heartbroken	Date: _____	distant	Date: _____

intense Date: _____

stretched Date: _____

doubtful Date: _____

uneven Date: _____

still Date: _____

hopeful Date: _____

nervous Date: _____

steady Date: _____

balanced Date: _____

complex Date: _____

excited Date: _____

ecstatic Date: _____

complete Date: _____

clear Date: _____

vulnerable Date: _____

grateful Date: _____

content Date: _____

blissful Date: _____

anxious Date: _____

curious Date: _____

defiant Date: _____

inspired Date: _____

restored Date: _____

hesitant Date: _____

courageous Date: _____

hidden Date: _____

frustrated Date: _____

lost Date: _____

cramped Date: _____

extended Date: _____

limited	Date: _____	bold	Date: _____	grounded	Date: _____
encouraged	Date: _____	joyful	Date: _____	fertile	Date: _____
whimsical	Date: _____	exposed	Date: _____	inventive	Date: _____
confident	Date: _____	heavy	Date: _____	playful	Date: _____
strong	Date: _____	solitary	Date: _____	pensive	Date: _____
weak	Date: _____	stuck	Date: _____	forgotten	Date: _____
spent	Date: _____	happy	Date: _____	conflicted	Date: _____
fearful	Date: _____	dormant	Date: _____	desired	Date: _____
rushed	Date: _____	fresh	Date: _____	uneasy	Date: _____
peaceful	Date: _____	aggressive	Date: _____	wishful	Date: _____

FIND YOUR FOCUS

Now that you've had some time to stretch your view by experimenting with your approach to making and processing images with your iPhone, I encourage you to lend a bit more focus to your approach—to shoot less of everything and more of something. Try to take a broader look at a narrower concept or subject and create a collection of images that tells a story or explore a unique approach.

Cultivating a series-based approach to this type of photography can lend some much-needed structure to help harness your creativity. Just as an artist can feel overwhelmed by a blank canvas or a vast array of paint colors to choose from, a photographer can feel overwhelmed by visual stimulation. There are so many ways one can approach the image-making process, and even more ways to digitally manipulate an image. By defining one or more series or projects, and coming up with a set of guidelines for your photographic study,

you can focus your creative energy in a more direct way. Just as a poet might feel comfortable composing thoughts within a defined structure, or an artist might limit his or her raw materials and dimensions before beginning a sculpture, take some time to consider your subject matter, approach, and perspective before you begin shooting, and you will most likely find the work flows more easily.

In this chapter, I'll introduce you to nine avid iPhoneographers who approach their iPhoneography in very different ways. Each has channeled his or her creativity in the form of personal projects that have helped define their unique visual vocabulary. We'll trace each iPhoneographer's path to iPhoneography, learn about some of their favorite apps, uncover the inspiration behind their personal projects, and look at some of their images. Then, we'll get you started on a project of your own to help you find your focus.

Try This

Why don't you ask someone you know (or don't know) to suggest a subject for your focus? I posted a tweet to my Twitter followers to suggest a subject for a new image series and chose @netmongrel's suggestion to shoot hubcaps. I spent a solid afternoon studying the wheels of cars in parking lots around town. During this time, I created a 13-image "Hubcap Art" series using Hipstamatic with Pistil film and the John S lens to give the series a common image size and color palette, so the viewer could focus on the variety of shapes and details of hubcaps portrayed in these close-up images.

DIXON HAMBY

Dixon Hamby began to explore photography and graphic arts in 1968 at age 23 when he enrolled in a Visual Communications program at Western Washington University. He'd always had a natural bent toward technology and an interest in photojournalism, and wanted to pursue a career he could do with his hands. At the time, though, he didn't envision himself as a photographer.

Connect Online

Location—Seattle, Washington, USA
Web Address—www.dixonhamby.tumblr.com
Twitter—dixonhamby

"Photography keeps me in the present. It's essentially a part of my life. No matter what problem I've had, I've always been able to take pictures. Photography makes me see the world and helps me shift my focus off my own problems."

Dixon's "Pole Art and the Street" Series

Dixon lives in an eclectic Seattle neighborhood known as Capitol Hill. "When I moved back to Seattle, I got rid of my car. So I walk a lot, and I began to notice this amazing art—these posters on telephone poles. They changed weekly, so there was always something new to see." One day, Dixon spotted a really striking image on a poster. "I lifted up my iPhone, turned it horizontally to make an image, and then I noticed these guys talking on the street behind the poster. Seeing the vivid fictional intensity of the poster and the connection of it within the reality of the street environment intrigued me. Now I can't help but walk down the street and make these unique connections."

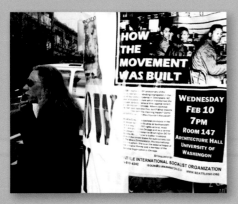

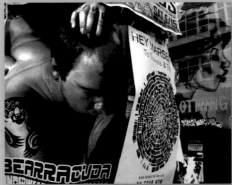

DIXON HAMBY

After graduating, Dixon landed a position as a graphic designer for The Boeing Company, a major aerospace corporation, while nurturing a growing interest in photography. Standing at the forefront of technology, he was among the first people in the world to use a computer for graphic design and evaluate the first beta version of Adobe Photoshop. In the early 1990s, Dixon's excitement about the potential of the Internet as a medium for visual communications began to grow. He learned basic HTML from a friend in an online chat room, and created one of the first photography websites.

After an 18-year career at Boeing, Dixon lost his job and took a leap of faith to pursue freelance travel photography. Shortly thereafter, while living in Panama, a palm frond fell on his head, damaging cervical vertebrae and his nervous system. The injury led to fibromyalgia, a condition characterized by constant pain. Dixon could no longer hold the weight of his digital SLR camera without suffering.

"In February 2009, I bought a 3G iPhone, and noticed that it came with a camera. I thought 'Hey, wait a minute, I've got a camera here.' So the iPhone was really a healing tool for me. Because of the fibromyalgia, I couldn't do very much so I had a lot of time to take photos with my iPhone and explore social media, particularly Twitter, as a method of sharing iPhone images and information about new camera apps with other iPhoneographers around the world."

Today, Dixon self-publishes books and sells prints of his iPhone images, teaches Twitter classes at a local college, and serves as a social media tutor to artists and photographers. Beyond his global iPhoneography community engagement, Dixon has organized photography TweetUps to connect in person with Seattle-based photographers, and has shown his iPhone images in numerous exhibitions around the world.

Exhibited at:

- Pixels At An Exhibition, Berkeley, California
- iPhoneography and the Automobile Exhibition 2010, Milan, Italy
- EYE'EM Exhibition 2010, Berlin, Germany

"None of my iPhone images are [representative of] how things really look but that's what makes iPhoneography so powerful. It's the fact that you carry your darkroom with you . . . in your hand. iPhoneography is unique because of the flexibility and growing number of apps you can use to manipulate your photos."

Dixon's Frequently Used Apps

Dixon uses at least two apps and sometimes three to create each of his images:

- **Perfectly Clear**: to shoot sharp, detailed images.
- **CameraPlus Pro**: to add outrageous, vivid colors to his street scenes.
- **PS Mobile**: to adjust contrast and convert his images of people and animals to black and white.

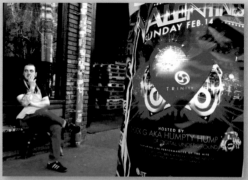

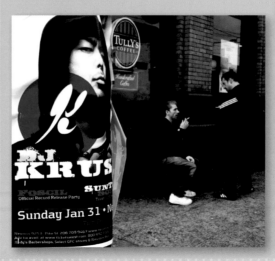

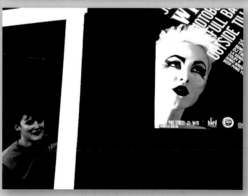

BOB SPRANKLE

Bob Sprankle began to explore photography in 1983 when he signed up for a black-and-white photography course at a nearby college. He rode the bus to and from the darkroom and spent all day manipulating prints with chemicals. His fascination with image processing skyrocketed in the dawn of digital photography and led to his early mastery of Photoshop. "I actually like to keep my bad photos and make something good in Photoshop. I've always liked that challenge. It's rare that I take a photo and say, 'Oh, that's done.'"

A public elementary school technology integrator by day, Bob brings a blend of creativity and technology into the classroom and inspires more than 500 students from kindergarten through fourth grade each year. Bob once challenged his students to use inexpensive digital cameras to document artifacts from their homes. But the real excitement came when he taught the children to experiment with image manipulation. "I'd watch the kids try something and they'd say, 'Okay, I'm done.' But then I'd encourage them to take it back to the original image and try something completely different. It was very cool to watch them see the value of revisions and take different chances with their images."

Connect Online

Location—Wells, Maine, USA
Web Address—http://bobsprankle.posterous.com
Twitter—bobsprankle
Instagram—bobsprankle

Bob's "Passerbys" Series

"One day, I was sitting on a bench waiting for a friend and I just started watching the people who passed by me during a 20-minute period of time. These people didn't know I was making images of them. I'd just raise my iPhone and shoot." But Bob is careful to distort the view enough to make strangers not easily identifiable. This series of images was processed using **TiltShiftGen**, to bring people in and out of focus, and **ShakeItPhoto** to apply a Polaroid-esque style.

"Using photography apps has changed my whole approach to digital manipulation. I'm saving hours of what I would have done manually in Photoshop. It's amazing that I can carry this iPhone around with me, and that it can enable high-quality image manipulation right from my hip."

BOB SPRANKLE

Bob didn't initially see the potential of his iPhone as a replacement for his SLR camera—in fact, he purchased it in 2008 to serve primarily as a reading device. "Then I started seeing these inexpensive photography apps appear. So I purchased and tried a bunch of them, and in no time my iPhone became the camera that's with me all the time."

Bob began Project 365 (a popular Flickr group and online photography project in which thousands of photographers shoot and share one image to represent each day for 365 consecutive days) on October 19, 2009, but shooting and sharing just one image each day wasn't enough, so he started a separate online journal with Posterous to organize and present short-term projects such as processing experiments on a single image, or different images of a single subject.

Bob's "Fragment" Series

Inspiration often comes in moments of pause. Bob had just buzzed his hair and was lying in bed reading online journals on his iPhone. Using Hipstamatic, he started shooting a variety of close-up views of his head on the pillow. "When I saw the images, I thought, wow, what would happen if I put those together using **Photoshop**?" He followed this inspiration, and continued to experiment with shooting different views of an image, shrinking the size of select images to create depth, and recreating the image by layering and overlapping the images. Bob admits that some of his image experiments fail miserably. He's spent three hours working on a single montage in **Photoshop** before finally abandoning it.

Sharing this series in his iPhoneography journal prompted a spirited Twitter discussion among iPhoneographers about the boundaries of iPhoneography. Can a photographer manipulate images outside of the iPhone (using **Photoshop** on a desktop computer, in Bob's case) and still call it iPhoneography? Some purists said no. Others were inspired, and applauded Bob's creativity. To Bob, a master of photo manipulation, the approach and digital tools don't matter. "Whatever it takes to make the best-quality image you can make [is what] works for me."

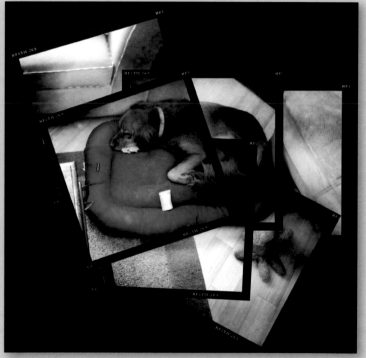

CHARLOTTA KRATZ

Charlotta Kratz remembers painting on the floor with her best friend as a child growing up in a small town on the west coast of Sweden. The young girls would balance their indoor creative pursuits with time outdoors, crafting make-believe stories in a wooded area behind her friend's home. "We would make up names for the trees, bushes, and particular stones—imagining that they were people or creatures. And we'd make up stories of things that happened to them." Despite her natural creative tendencies, Charlotta steered away from becoming a visual artist as she got older.

Connect Online

Location—San Francisco, California, USA
Web Address—http://lottak.posterous.com
Twitter—LottaK
Instagram—lottak

Blue/White

Hibiscus

Petals

"iPhoneography has connected me with another part of myself that I really appreciate. I've realized that I'm really a visual person, though I never thought of myself that way. It's made me into a different person in the eyes of others, in a way. And that makes me feel good, because it is true to who I am."

"My parents didn't think it was a good idea, so I kind of pushed it to the side. Intellectual pursuits were just easier for people to accept." She went on to achieve a master's degree in communication at the University of Göteborg and has an almost-finished PhD.

Charlotta is currently a lecturer in the Department of Communication at Santa Clara University in California, where she teaches courses in media and communication. While Charlotta had been attracted to photography as an artistic medium of creative expression for many years, she felt that she never had enough time to take it seriously until the day she borrowed a very small, inexpensive digital camera from her partner. "It was a revolution to me. I thought, 'it's easy, it's fast, it's lightweight, and I could use it everywhere.'" And suddenly, she was attracted to everything—shooting nearly every day during a summer visit to Sweden, "something just shifted" for her.

Purple Rain

CHARLOTTA KRATZ

Bend

Swirl

Charlotta's Frequently Used App

Hipstamatic: Charlotta likes the simplicity and efficiency of making the processing decision before she shoots her images, though she rarely changes her film and lens setting. Shooting with just one app keeps her focus on shooting, and lets her seek creativity in composition and light within the boundaries of her processing decision.

Excited by her experience with that first camera, Charlotta purchased a digital SLR, but hesitated to use it because of its cumbersome size, weight, and complexity. In the summer of 2009, she bought an iPhone. Unimpressed by the native camera, she didn't even consider using the iPhone as her primary camera until she downloaded the Hipstamatic camera app six months later. Charlotta's fascination with photography renewed itself in the form of iPhoneography as she quickly made Hipstamatic images of the road on a drive that lasted several hours.

Charlotta is also attracted to organic shapes found within the landscape as she walks familiar trails—she deconstructs horizons with her lens into simple shapes and basic visual elements. "The world is really overwhelming and through my images I like to reduce it down to simple elements that I can grasp." Attracted by the angles or lines of natural elements or light, she shoots an image using Hipstamatic often only once because each high-quality image requires several moments to process and generate a digital "print." For Charlotta, iPhoneography is a tool that helps simplify her view of the world; it serves as an efficient medium of creative expression.

Charlotta's Focus on Nature

Charlotta most often points her iPhone toward nature, specifically flowers—an interest cultivated by a love of gardening passed down from her mother and her grandfather. While Charlotta doesn't tend a garden of her own, she's attracted to the color, shapes, and texture of flowers found in the shade on frequent walks in her neighborhood. "I really love flowers. They're so expressive. It reminds me of the way my friend and I connected with nature when we were children, how we saw them as people or creatures. If you get close enough to a flower, you only see the colors. [There's a point when what you're seeing] is not really a flower anymore. And I like that, when it goes beyond what it is and becomes something else."

"I think it's okay to be a little bit obsessive, to do things over and over again. Allow yourself to be like that. If you like flowers, shoot flowers. If you like the results of one app, shoot with that one app."

KEITH WEAVER

At age four, Keith Weaver remembers standing under a red light in a small bathroom-turned-darkroom, watching his father make images appear on paper like magic. Those early moments and time spent with his dad's Minolta camera marked the beginning of his fascination with photography as a medium for sharing his view of the world.

Keith went on to obtain a BFA in Graphic Design at the University of Massachusetts, Lowell, and credits his first photography instructor, Arno Minkkinen, for teaching him how to think conceptually—"to take down all the barriers of everything you've been taught as right or wrong and just explore—to let yourself go creatively and not feel like you have to define it or put it in a box." With his dad's old film-based SLR, Keith explored the streets of Boston for weeks on end, capturing graphic images of architecture and the urban landscape under different lighting conditions. During the mid-1990s, Keith quickly took to the web as a medium for expression and began experimenting with new technologies outside of his day-to-day tasks at a graphic design firm. He was excited by the complexity of interactive design and soon mastered the ability to simplify user experiences without compromising design esthetics. Now a creative director, Keith directs teams of interactive designers and helps transform globally-recognized brands to connect with their consumers in more innovative ways.

Connect Online

Location—Atlanta, Georgia, USA
Web Address—www.keithweaver.com
Twitter—keithweaver
Instagram—keithweaver

"As a creative person, you have to constantly find things that are interesting to you and express ideas that pop in your head, or express your view of the world around you, or what's inside you. The best creatives are the people who inject their own personal experiences in their work."

Excited by new technology, Keith purchased the original iPhone three years ago, but didn't really get excited about the camera until he downloaded CameraBag. "With CameraBag, I could see that I could put a more artistic spin on these bland photos [shot with the native camera] and saw that I could instantly upload and share them through Flickr and Facebook. It was the aha moment, and I began to explore [the iPhone camera] as a real medium for creative expression."

Keith liked the fact that few other people had yet to discover this and that he could instantly share a moment. "By early 2009 there was an explosion in my social network and I was connecting with creative people all over the world doing similar things in the social space. Sharing iPhone images with each other online] helped legitimize iPhoneography. Suddenly it wasn't just about people running around with little cameras; real artists emerged, making unique art within the construct of the technology."

Keith's 10X20 Project:
An iPhoneography Adventure Around the World

Keith was laid off from his job at the end of 2009, placing him in an introspective state. Although he was beginning to attract interest in his iPhoneography from exhibitors, shooting with the iPhone was beginning to lose its luster for him. "I was thinking about what I wanted to do in 2010. I knew I needed to find another job but I wanted something else to fulfill me. I was thinking about the fact that I hadn't traveled much, so I came up with this idea to travel to 10 places I had never visited and to just explore and shoot photos over the course of a year or so." He liked the idea of shooting fewer random images and channeling his iPhoneography to create a body of work that would connect and showcase a collection of stories into a broader narrative.

"I wanted the challenge of going to a place, capturing hundreds or thousands of photos and limiting myself to craft a story with just 20 photographs from each city. Each city has its own feeling. So the 20 images that represent London have a certain hue and a tone, and a feeling because of the bleak weather and the way I experienced that city with my brother. Paris has a more fresh, 1960s' vintage feeling, conveying the subdued brightness of [the city] because it was sunny and I was there with my wife, and it was just an amazing experience. Iceland will have minimal filtering to convey the wonderment and pristine, almost earthly beauty of nature I experienced alone on that trip."

Keith shoots very modern, clear, and simple moments or spaces that could easily go unnoticed, striving to make viewers feel as though they are traveling on the journey with him, seeing the city through his eyes. Keith uses the native iPhone camera and a minimalist approach to processing, using just one or two color filters in CameraBag or Mill Color to apply a subtle mood or tone for a sequence of images.

KEITH WEAVER

10x20 Project, London

10x20 Project, London

"With the iPhone, expectations are lower and people are amazed at what you can get. You can blend into your environment and you don't have to be so obvious about who you are or what you're doing, and that lets you find better things and explore and express yourself in a better way, when that barrier is down."

10x20 Project, Paris

10x20 Project, Iceland

10x20 Project, Paris

10x20 Project, Iceland

FRANCE FREEMAN

Raised in a creative extended family, France Freeman inherited a love of the arts as a young child and was especially influenced by her single mother, who was a college student when France was young. Her mother would sometimes bring France along to her art classes and theater productions, and encouraged France's artistic pursuits. "I grew up in that atmosphere, dabbling in many arts—drawing, dance, music, theater, creative writing, and photography—but never feeling I'd found my focus."

It wasn't until college, while studying film, that France realized she had a real eye and love for photography. Focusing on the path of visual story and

Connect Online

Location—Seattle, Washington, USA
Web Address—http://iphoneographybyfrance.posterous.com/
Twitter—francemarie
Instagram—francemarie

"Part of the beauty of shooting with the iPhone is that it is limited. Like a haiku, you're forced to work within certain confines. Because you can't change lenses, aperture, or shutter speed settings, your control is limited to your vision and your perspective. Shooting in these constraints strengthens you in certain ways, while exploring creative processing options with different apps gives you the freedom to make your images look unique."

veering toward film, she pursed radio and television communications at California State University, Northridge, with a focus in screenwriting, and started taking pictures for friends and aspiring actresses in Los Angeles. "That's when I started doing my photo walkabouts. I liked to travel and explore, so I would pick a place, grab my camera and just wander for hours, photographing whatever captured my interest."

When France left LA and the film industry for Seattle, she began working at a one-hour photo lab while pursuing freelance portrait photography. Her one-hour photo lab job turned into a position within the publishing division of the major retail company. Soon after, France helped launch the company's first photography studio, where she now shoots products, food, and models on a daily basis. And although her professional photography career has been rewarding, France found that it wasn't fulfilling her personal need for self-exploration and creative expression. "I shoot professionally in a neutral gray, windowless

Foreign Landscape

FIND YOUR FOCUS

FRANCE FREEMAN

studio and by the end of the day, I'm not inspired
to haul a big camera and gear bag around. But
when I got my iPhone in November 2008 and started
experimenting with the CameraBag app, suddenly I had
a renewed desire to start 'playing' with photography
again outside the confines of the studio. Making images
with my iPhone helped me to loosen up my thinking
and be a lot more creative. It gave me a new feeling of
inspiration inside the studio and out."

Scenes from the seaside (left and above).

France's Frequently Used Apps

- **Hipstamatic**: To achieve a quick and dramatic look. She favors the John S black-and-white lens with BlacKeys Super Grain film for a high-contrast B&W film look, or Kodot film, for a toned color look as shown in her beach series. "I love the uneven vignetting, subtle textures, and saturated blue-green hues. It works really beautifully with the overcast skies we often have here in the Pacific Northwest."

- **Pic Grunger**: To add texture, for a weathered, aged, organic feel. France uses multiple layers of texture to obscure some elements while emphasizing others to create images that have an air of mystery and timelessness.

- **Picture Show**: To experiment with randomized multiple exposure effects and mirroring, and to apply a variety of image borders and color-and-light effects.

Scenes from the seaside (above and right).

FRANCE FREEMAN

Creative Techniques by France Freeman

One issue with using the same filter repeatedly is that you can start getting a uniform, predictable look to your images. To create a unique look, I use a few different techniques:

- **Keep a texture library**: Shoot a variety of close-up textures such as wood, rust, peeling paint, and walls, and use them as texture layers in an app that enables image layering such as Iris Photo Suite. You can adjust the look of layers to create a single image using different blending modes and opacity controls.

- **Rotate the camera**: When shooting with an app like Hipstamatic, I add variation by rotating my iPhone to different positions, so the vignette and texture will be applied in various positions on a group of images.

- **Create a filter layer**: If you like the look of Hipstamatic images, but don't want to limit your ability to apply a variety of techniques to a single image, you can create a similar look by taking a picture of a blank white wall with the Hipstamatic camera using your desired film and lens setting. You can then use this image as a texture layer in an app such as Iris Photo Suite. Consider rotating your filters for additional variation.

The Hammering Man

France's Journey Through Mystical Scenes

Most of France's images appear as scenes from mystical lands. It's as if each image emerges from the layers of a dream. Heavily textured, drenched in color, and almost collage-like in their feel, France shoots with the native iPhone camera and applies multiple layers of filters and image effects to make the subject matter of her images less obvious. "I like images that make you think of dreams and memories, but not using obvious symbols. Just as you can become intrigued with a dream you've had that makes no logical sense, it can still speak to you on an intuitive level. There's no preconceived thought process to my images; it's more organic. I play. I experiment. I just keep following the path of the story through the image, adding layers and textures, until I feel it's complete."

While France doesn't consciously plan projects in advance, a collection of images often emerges in the form of a series. "I might create 10 to 20 images with a certain feel, but I don't like it when images become too predictable." France enjoys trying new apps, but continuously strives to set her images apart from a standard single-filter look by layering apps and filters, making it nearly impossible to discern what apps were used in the creation of her images. "I want to be able to put my own stamp on it and create something uniquely me."

"A dream, Adrift" under blue-green waters sank the dock to home, so on floating planks drift to a place unknown.

"I'm less concerned with capturing reality than I am the inner landscape. Like a Rorschach test, I believe that what we choose to photograph often reveals more about our inner self than it does our subject."

TOM WARD

Tom Ward has always been artistic and eager for hands-on creative activities that blend technology with creativity—playing with electronics, building models, and taking photographs with a point-and-shoot camera thanks to encouragement from his stepfather, an avid amateur photographer. Tom's lens was initially attracted to most everything, but later yielded images that portrayed very graphic shapes—sweeping lines and hard edges found within the urban landscape of Coventry, his birthplace in the United Kingdom.

Tom's focus on photography gained momentum slowly. He took photography as one of his General Certificate of Secondary Education classes in his final two years of school, and then went on to graduate from

Connect Online

Location—Birmingham, United Kingdom
Web Address—http://www.tomwardphotography.co.uk
Twitter—TomWardPhoto

"Like the original Hipstamatic or Holga film cameras or the Polaroid camera, the simplicity of the iPhone strips a photograph down to its core component— composition."

a two-year photography course at Coventry Tech in 2005. "At that time, I had no idea what I wanted to do with my life. I had always taken pictures, but I would never have described myself as a photographer. I didn't think it would flourish into something that I could sustain as a job. I did it for the love of taking

FIND YOUR FOCUS

TOM WARD

pictures." But his time spent both in the darkroom and studying the work of noted photographers, including Edward Weston, Bill Brandt, and Karl Blossfeldt, became a catalyst. Tom went on to pursue a BA Hon in Photography at Falmouth College of Arts. Today, his freelance photography career straddles the line between commercial and fine-art photography, while he balances a studio day job, shooting products for e-commerce websites.

Tom first began to experiment with the original iPhone camera in 2009. To compensate for the lack of clarity and color issues in early iPhone images, he would export images to his computer and sharpen them and adjust color balance using Photoshop (just as he did for nearly all of his SLR images). Tom had always shot with post-production in mind, so processing his iPhone images outside the camera came naturally until he started downloading and using simple apps such as Hipstamatic and Format126.

Tom's Frequently Used App

Format126: To apply simple visual effects to his images (shot with the native iPhone camera) such as ColorPlus to add an extra boost of color, PolaColor to apply a retro Polaroid look, ColorHint to bleach out all but the strongest colors in his photos, and options to add vignettes and borders or apply a square format to his images.

Tom's Consistent Style

Staying true to his focus on architecture and visual style characterized by graphic imagery, sharp color contrast, and angular composition, Tom's iPhone images have remained consistent with the style of his SLR images. His iPhone images blend seamlessly into his professional portfolio. "I did all of my experimentation through my schooling. I'm very privileged to have come out the other side having a visual language. In the first year of my degree, I remember my lecturers talking about finding your practice—finding something that is intrinsic to you—and almost laughing at the concept of having your own style. I couldn't envision ever having something that someone could identify as my definitive language. But I definitely feel I have achieved that. Whether I'm happy with what I produce or not is another thing."

"iPhoneography has made me more conceptual . . . I tend to overthink things a bit. [iPhoneography has] made me more blasé toward shooting. Prior to my iPhone, my camera only went out with me when I was going on a shoot. I had that preconception that 'today I'm going to shoot this and it's going to look like this' because I've always got an image in my head prior to shooting. But with the iPhone, I haven't."

Tom's "Enclosure" Series

Tom's enclosure series of images made at the Twycross Zoo demonstrates his appreciation for the spontaneity iPhoneography brings to his fine-art photography. "It was my sister's birthday and I didn't intend to take pictures at the zoo that day. Since college, I've always been interested in empty enclosures—places that are built for a very utilitarian purpose, but have not lived up to their intended purpose. I had taken a lot of pictures of empty play areas and empty park benches." When Tom encountered these old-style enclosures at the zoo, he was naturally inspired to capture the unsettling relationship between the enclosures and inhabitants. Thankful for the presence of his iPhone, Tom was able to expand his long-term series that day—shooting each of these images with the native iPhone camera and applying the ColorPlus and ColorHint filter in the Format126 app to achieve a style true to his vision.

DOMINIQUE JOST

As a child, Dominique began expressing himself and his view of the world through images and stories by drawing comics. In spite of the fact that his father's secret passion was black-and-white photography and Dominique was surrounded by his father's camera gear and expanding image collection, photography wasn't anything he thought about seriously for himself. He considered the digital process of downloading images from a camera and uploading them to a computer for processing clumsy and time-consuming. Leaning more toward the analytical side of his brain, Dominique applied his curiosity and creativity to computer science, and currently leads teams of developers in the creation of Internet and mobile software applications.

Connect Online

Location—Bern, Switzerland
Web Address—http://www.nique88888.com/

Twitter—domjost
Instagram—nique88888

Dominique's interest in photography sparked with the iPhone camera in 2008 when it coincided with his passion for technology. Intrigued with the ability to quickly process images with mobile apps and publish images to his Tumblr blog directly from his iPhone, he began to shoot daily. "At the beginning it was just about experimenting with apps and post processing. I tried a lot of different techniques just to be geeky and see what would come out of it." But when Dominique discovered the street photography of iPhoneographers Sion Fullana (www.sionfullana.com) and Greg Schmigel (http://justwhatisee.com), things clicked creatively. "When I saw their images, it just blew me away. I thought, 'if these guys can produce spectacular images

like this on an iPhone, then I'm holding something powerful in my hands. I need to stretch the possibilities as much as I can and see what I can do with the iPhone.'" So Dominique created a Twitter account and began to follow and share his iPhone images.

As Dominique's approach to iPhoneography matured, he became less focused on image processing and more focused on shooting—narrowing his subject matter to spontaneously document strangers in scenes found within walking distance of his home in Bern, Switzerland. In spite of his early enthusiasm around mobile photography, the birth of Dominique's son shifted his point of focus. Embracing family life and a commitment to his career pulled much of his inspiration away from iPhoneography. "I found it hard to get back into flow, and my images just didn't feel right anymore. It was as if something had left me." On September 10, 2011, Dominique shared a heartfelt note of thanks on his website and announced his departure from the mobile photography community of contributors. Perhaps one day he'll return.

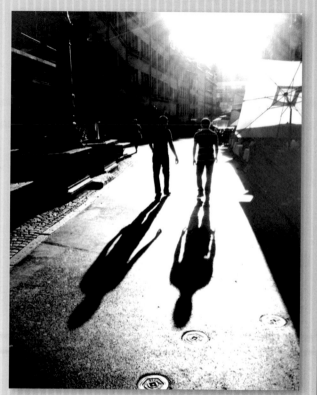

They Walk Among Us

"There's this spider sense of anticipation I get, like I know something is going to happen. I don't really look for it, but I can tell by the presence of light and the setting that something's going to happen. That's when I pull out my iPhone."

DOMINIQUE JOST

Dominique's Frequently Used Apps

- **CameraBag**: To quickly apply the 1962 filter to convert his color images shot with the native camera to high-contrast black and white. Citing it as one of the first apps he ever used, he admits he continues to use it for sentimental reasons.
- **Cool fx**: To quickly apply one or more black-and-white or monochromatic filters and grains.

Dominique talks about the thrill he feels at the moment he clicks the shutter, but "it's rare that that feeling carries on over a long period of time. So I take pictures, edit them quickly on my iPhone and then I'm done with them." Dominique prefers a light-handed approach to image processing and avoids apps that preset more stylized image effects, so his images remain true to life.

Milano.Swagger

Jump.Jump.Aha.Aha.

Heimspiel

Dominique's Self-Portraits

Many of Dominique's images contain the presence of his shadow in the setting. Intrigued by the shapes and texture of shadows within a composition, Dominique initially explored self-portraiture (or "selfies" as he calls them) because he needed a subject. "My self-portraiture is not really about me, it's more that I'm just a part of the whole puzzle that is the picture. I would happily put someone else in that position, but at that moment, in that time, there is no one else there but me. I'm just an additional prop or element of the whole composition."

 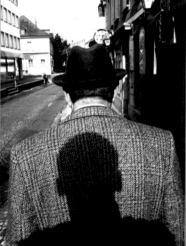 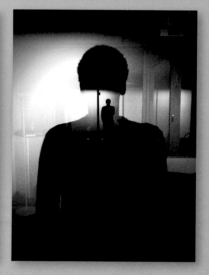

"I still find it a bit strange to talk about my work as art, because I don't have an artistic background. iPhoneography has pushed me physically into different places and scenarios, but it's also pushed me mentally. I'm not the same person I was two years ago in that now I'm actually producing something that others would call art, as opposed to just consuming art."

MAX BERKOWITZ

Max grew up surrounded by creativity and inspired by his mother, T.R. Miller, a painter, sculptor, writer, and art educator. In the 1970s, she'd frequently invite the neighborhood kids to their house and involve them in the process of making art. When *MAD* magazine and a light table appeared in Max's home, he began to draw and cartoon regularly. Challenged a few years later by his parents' painful divorce, Max remembers his high-school years as a difficult time of transition in his life. It was during this time that he found an interest in photography and spent hours developing black-and-white images in a small bathroom-turned-darkroom in the attic.

Connect Online

Location—Sacramento, California, USA
Web Address—http://maxsiphotos.tumblr.com/
Twitter—MAXSiPHOTOS
Instagram—maxsiphotos

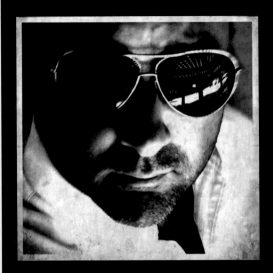

"As a curious person, I've tried all different types of photographic approaches. Much like the path of my life, the art of my photographs shifts and changes. Sometimes I like to go back through my image archive and see where I was at a certain point in time—to follow the evolution."

Once the process of making images became routine for Max, his creative interest turned toward video production, and then on to music in the mid-1980s. "I'm always eager to try something new." Nearing completion of his bachelor of arts degree, Max dropped out of college to pursue a variety of career paths before settling down in Sacramento, California, to start a family and his own restaurant, Max's Deli and Catering Company, with his father, Al "Sonny" Berkowitz.

It was the iPhone that re-ignited his interest in photography two years ago. "I've always been inspired by the work of iPhoneographers who focus on black-and-white street photography. But for me, a suburban dad, I'm not downtown, not walking the streets. The only time I have to shoot photographs is when my children are swimming or playing soccer and that takes up a lot of my free time. So I realized that after shooting a few images and documenting these moments with my children, that became my street photography."

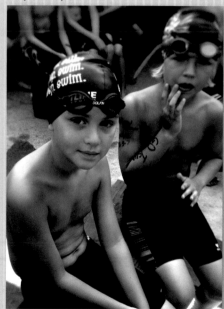

Ready Bench Boys

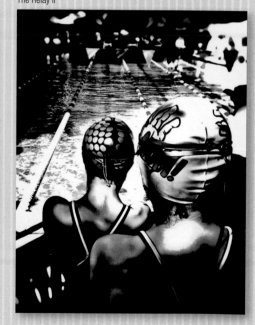

The Relay II

FIND YOUR FOCUS

MAX BERKOWITZ

Always curious and eager to experiment, Max identifies a list of his top 20 apps on his website and typically carries more than 3,000 images on his iPhone at all times. He might shoot an image and let it sit on his iPhone for several weeks before making a decision on how to process it with one or many apps and eventually publish the finished image to his Tumblr site. "I was a little leery of putting my images online as it opens you up to getting good and bad comments. It took a while for me to feel comfortable sharing my real name, images of my kids, and my life with people I don't know. It requires a certain amount of trust."

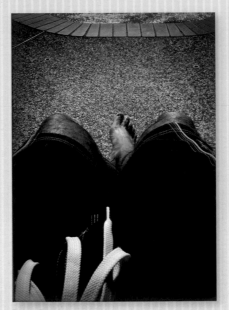

Fathers Day

Flipped Flops

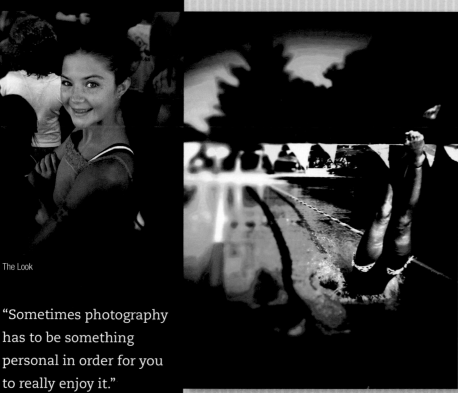

The Look

"Sometimes photography has to be something personal in order for you to really enjoy it."

The Diver

Max claims that many of his best images are made by accident. A prime example of this is his image, *The Diver*. "I didn't set out to make this image. I was trying to capture this particular swimmer in mid-air and ended up with this image of her halfway in and halfway out of the water. I almost deleted the image and then thought 'well, maybe I'll look at this image differently in a week or two and see something I'm not seeing now.'" So he let the image sit for several weeks and then processed it first with the TiltShiftGen app to adjust depth of field, and then over-saturated the colors and cropped the image using the PhotoGene app. After he published the finished image on Flickr and on his Tumblr site, it attracted thousands of views and comments. Receiving feedback from an online audience has been invaluable to Max's evolution as an iPhoneographer. "I'm fascinated with the feedback I get from people and I realize that I'm not always the best judge of what people like. Do their comments influence the direction of my images and keep me from deleting images more often than not? Maybe."

FIND YOUR FOCUS

JESSE WRIGHT

Jesse came to photography by way of scientific research. As a microbiologist, he was studying bacterial communities in the lab and needed a way to document their interactions. Accustomed to communicating the findings of his experiments in verbal and written form, he decided to bring a camera into the lab one day. His colleagues immediately saw the impact of his results after he shared them in the form of a photograph. "That's when I realized the power of photography. As a natural experimenter, I thought, 'Where could I go with this?' It was another tool I could use to see and explore. I thought, 'Now I can go outside the lab and study the world.'"

Growing up in a large family of six children and as a former college football player, Jesse has always balanced being part of a team with a desire to stand apart. Photography allows him to express his thoughts and emotions through images. "I feel there's a sense of loneliness that comes out in my pictures—this frustration that people don't listen. In spite of the fact that I live in New York City, there are not a lot of people in my shots, but I see that one person thinking. I see that loneliness. I want to make my way past the group of smiling people at a party to the back of the room and find that one person who may not be having a good time. That person is interesting to me."

Connect Online

Location—New York, USA
Web Address—http://jessewrightphoto.com/
Twitter—jessewright
Instagram—jessewright

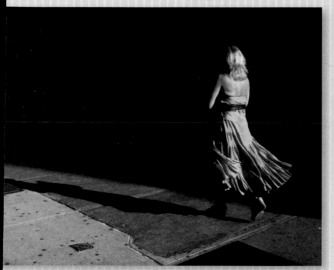

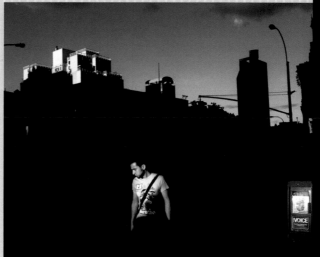

Challenged by a shortage of funding, Jesse left his career as a practicing scientist several years after he obtained his PhD, and subsequently went to work as a medical director for a marketing and communications agency for healthcare industry clients. At the same time, he continued to fuel his passion for photography. "I pour my emotions into my photography. It might be cliché, but I do feel like there has to be a certain amount of pain and frustration to inspire me to make images. I listen to my gut a lot to see how I feel. Maybe I'm a little cynical one day and I capture that. Or maybe I feel lonely and want to go off on my own and take a photograph to convey that feeling. And I like that . . . pouring that emotional energy into my photography."

"I've always been a naturally curious person. I want to challenge my environment, explore it, and see what's happening. Having a camera feels very natural to me. It's much less of a scientific tool now, but I still approach photography like a scientist. It's a way for me to ask questions about the world and view the variables."

FIND YOUR FOCUS

JESSE WRIGHT

While Jesse does shoot with a high-end SLR, he frequently shoots with his iPhone because it's always on him and because it's unobtrusive. He likes having the ability to make images of individuals on the streets of New York City without drawing attention to himself. "If I have my big, black camera and I put it up to my eye, all of a sudden, I've changed the environment. I'm not capturing something organic and native anymore."

Jesse thoroughly enjoys the challenge of working within the shooting constraints of the iPhone. "The iPhone can't do everything I want it to do. It responds to light in ways that limit my control, and while I might not like it, I think to myself, 'Let's use it, celebrate it, and really push its boundaries.'" As the quality of the iPhone camera improved, Jesse found that he wanted to have more control over image processing. "I treat the iPhone like my SLR camera now, where I take pictures with the native camera, download them once a week and process them using Photoshop. iPhone photos get the same respect and level of treatment from me—they're treated just like any other picture I take."

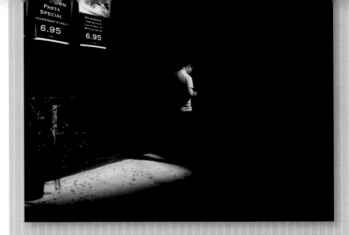

"I like it when people tell me that my images make them stop and think. Life can be so overwhelming sometimes. You get to a point where you're just reacting and you're not seeing. Photography is me seeing. This is what I need to do. I need to stop. I need to see my surroundings."

Jesse's Umbrella Series

For Jesse, an idea for a series might emerge serendipitously and give him a visual platform to communicate a simple discovery. In fact, the "Umbrella" series found him when he discovered a pattern of discarded umbrellas one late spring afternoon along Sixth Avenue in New York City. "I went out to get coffee after a really bad rainstorm and noticed discarded umbrellas all over the sidewalks, and in the street. Once I saw the pattern, I was absolutely compelled to make the series. I was so happy, just exploring these totally trashed umbrellas for nearly three hours." But there was something else that intrigued him about the perceived value of umbrellas. "When it rains, there's always a lot of conversation around umbrellas: 'Do you have your umbrella? Did you lose your umbrella?' When someone leaves their umbrella somewhere they're just distraught. But, it's worth ten bucks, and they're so disposable—they break constantly. As soon as it doesn't serve you anymore, it's gone. People just throw umbrellas to the ground. They don't even bother getting them to a trashcan. The contrast between how much people obsess over umbrellas and how quick they are to trash them was the idea behind this."

DEFINE YOUR PERSONAL PROJECT

Creating a series of images allows you to explore a concept or subject in a deeper way. You might discover threads of connection, sharp contrasts, subtle differences, or a broader view of your subject that couldn't have been conveyed in a single image.

Creating a series

For example, making one image of a father in a swimming pool throwing his daughter high in the air on a summer's day might translate as a playful moment. But creating a series of images of that same father throwing not only his daughter, but also his son, nieces, and a nephew in the swimming pool gives you an opportunity to:

• Immerse yourself in the joy of a summer and the bond between a family.

• Practice shooting in a scenario where you must anticipate the action.

• Explore diverse shapes of mid-air poses and varied texture of splashes.

• Imagine how the personality (or weight) of each child might impact their form.

• Study the father's patient actions (and expressions) in fulfilling repeated demands.

I challenge you to find your focus and define a series to begin. Offer a fresh perspective on an everyday action. Take us deep inside a place that's familiar to you. Help us make a connection through found objects. The scope, size, and length of time you devote to your project is up to you. You might start and finish a single series in five minutes, five hours, or five months. A series can be comprised of three images or 300, depending on your vision. However, before you begin shooting, consider setting some guidelines for yourself to visually connect the images in your series.

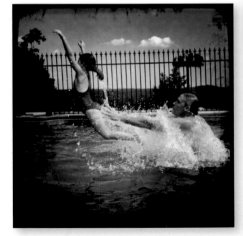

For this "Throw Me" series of images, I was focused on my children and their cousins making repeated "Throw me!" requests in the swimming pool. I used Hipstamatic with Float film because I knew it would darken the images shot in bright sunlight, offer a more even color wash across the variety of swimsuits, and portray a timeless look for the experience. I positioned myself close to the edge of the pool and requested that my subjects remain in that same position as each child was thrown into the air, so the viewer would focus his/her eye on the diversity of the throw action and the subtle activity surrounding it.

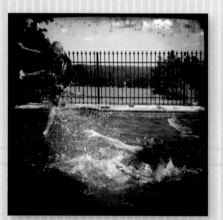 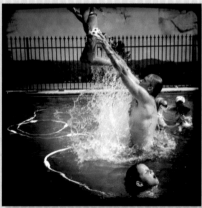 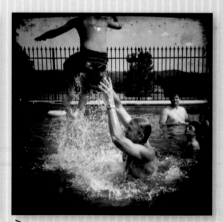

Guidelines might include:

Subject Matter: What is your focus? What do you want your images to reveal?

Consider: Person/people, place, thing, experience or concept (i.e., love, distance).

Processing Style: How will you portray the subject matter? What mood or emotion do you want it to evoke?

Consider: Color vs. black and white, the app you will use to make the images, processing filters or effects you will use on all images, border vs. borderless, image size, etc.

Perspective: Where will you stand and how will you hold the camera?

Consider: The placement of your feet in relation to your subject, the angle of your iPhone (a view from above, below, straight on), presence and direction of light, focal area, vertical vs. horizontal orientation.

JOIN THE COMMUNITY

True creative inspiration comes from within, but it's often sparked by our visual experiences. One way to expand your horizons and stretch your view is to share your iPhoneography online and to explore the work of other iPhoneographers traveling on a similar journey of creative expression.

In this chapter, we'll give you some ideas and example methods to get you started, but keep in mind that the list of online resources and social networking tools and apps to cultivate community continues to evolve and expand daily. For the most up-to-date information, explore iPhoneography resources online.

Post and Share Your Images in an Online Journal or Blog

If you want to present and share your iPhoneography as a method of visual documentary or creative expression in an online space unique to you, consider setting up and customizing the look and settings of an online journal (or photo blog).

Sharing your iPhoneography

Sharing your iPhoneography and following fellow iPhoneographers through online journals or blogs and social networks such as Flickr, Twitter, and Instagram are effective ways to:

- Present and track the evolution of your images.
- Encourage feedback on your images and share feedback with others.
- Explore and promote the work of fellow iPhoneographers.
- Pose questions and share answers with iPhoneographers.
- Learn about new photography apps and techniques.
- Keep up to date with iPhoneography news, exhibitions, and competitions.

Connect Online

Posterous Spaces—http://posterous.com/
Tumblr—http://www.tumblr.com/
Instagram—http://instagram.com/
Pinterest—http://pinterest.com/

Flickr—http://flickr.com/
Twitter—http://www.twitter.com/
Facebook—http://www.facebook.com/

For iPhoneography, you should consider a hosted-solution provider with journal customization and mobile publishing capabilities such as Posterous or Tumblr. This way, you can make an image with your iPhone camera and quickly publish it online to your Posterous Space or Tumblr account using the Posterous or Tumblr app on your iPhone. Or, you might choose Instagram as your primary publishing destination and have that app autopost your image to your Posterous, Tumblr, Flickr, Facebook, Twitter, and/or Pinterest account(s). Publishing your images in a personalized online journal in addition to your social networks gives you an opportunity to reach a broader community of viewers and increase interaction and conversation around your images.

Both Posterous Spaces (owned by Twitter) are easy-to-use and customizable online journal solutions. Because I use Posterous to power my personal iPhoneography journal, I've outlined some of the common actions for managing an online journal using the Posterous-hosted solution to show you how simple it is to use. New online journal or photo-sharing solutions are likely to become available over time. I suggest you explore iPhoneographer online journals, identify the ones you like best, and contact the iPhoneographer(s) to find out more about their experience. Most will be pleased to share their recommendations.

Posting an Image to Your Posterous Space Using the App

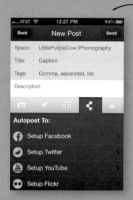

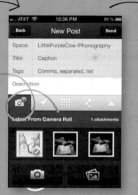

1 You can post images from your iPhone to your Posterous journal via email or via the Posterous app for greater control. Download and activate the Posterous app, then set up autopost functionality to extend the reach of your images to other social networks including Facebook and Twitter.

2 Create a "New Post" by tapping the camera icon to make a photograph or tapping the photo library icon to select an existing image. In this example, I chose an image from my photo library. To deselect the selected image, tap it.

3 Add a title and optional tags and/or a description for the image, then tap the "Send" button to post the image to your Posterous Space.

PHOTO JOURNALING

Building a Community of Followers in Posterous

Both Posterous and Tumblr encourage community-building by making it easy for iPhoneographers to follow each other's online journals. Your subscribers are alerted when you publish new images in your online journal, making it easy for them to stay connected with you. Both Posterous Spaces (owned by Twitter) and Tumblr are easy-to-use —here's how to manage your Posterous Space and connect with followers:

After you log into your account, click on the "Manage" button.

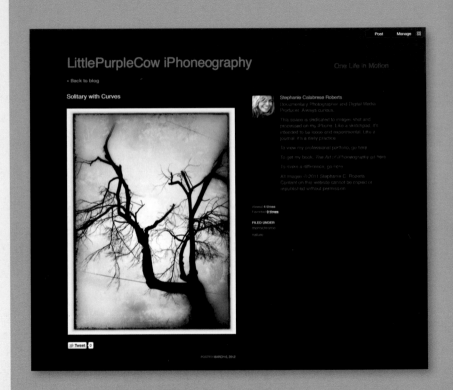

Click on the "Manage Members" button to view your list of members and followers.

View your followers and/or find friends in your Facebook and Twitter social networks.

Instagram

Beyond basic image editing, the Instagram app is a popular photography-based social network and a powerful mobile platform for discovering and following iPhoneographers, and sharing your own images.

PHOTO SHARING

Shoot, Edit, and Share your Photos in Instagram

Instagram (http://instagram.com/) is a photo editing and sharing app used by a thriving global community of millions of fellow iPhoneographers. You can set up a free Instagram account and instantly find and follow users you already follow in other social networks such as Facebook and Twitter. Using the Instagram app, you can shoot, edit, and annotate your photos, and/or simply use the app to publish your images to a community of Instagram followers. To extend the reach of your photo beyond Instagram, you can adjust settings in the app to autopublish specific images to your other social networks including Facebook, Twitter, Flickr, Posterous, and Tumblr. While I don't rely heavily on Instagram's photo-editing capabilities, what's particularly appealing about it is its community, and the simplicity of its photo sharing and viewing experience. Photos from you and people you follow in Instagram appear in a continuous stream in chronological order. Followers can quickly comment on or "like" your photos, giving you instant feedback. When followers like your photo, it's shared as a status update with their followers, making it efficient for Instagram users to discover you and your work. I've found many of my favorite photographers by scanning the status updates of people I follow.

Using Instagram

You can download and use the Instagram app on your iPhone to upload and share your images directly from your camera or iPhone photo library. To share a photo from your photo library:

1 Tap the camera icon, then tap the photo library icon and choose the image you want to share.

2 Tap and drag the image to move it. Pinch and expand your fingers to scale it. Tap "Choose."

3 Now you can edit the image (e.g., choose a filter, add a border, rotate it, choose an area of focus, etc.) or tap the green check mark to proceed and publish it.

4 Add a title or a caption, and an optional location, then choose your share settings for the photo. Tap "Done" when you are ready to publish, or tap "Filters" to return to the previous screen and continue editing.

5 The photo appears in your Instagram image feed where your followers can "like" and/or comment on your image.

6 The conversation icon reveals updates in your "News" feed, alerting you to new followers, likes, and comments.

PHOTO SHARING

Extending Posterous or Instagram with Twitter

If you are using Posterous or Instagram as your primary publishing destination, you can set up auto-publishing from either account to your Twitter and/or Facebook account to extend the reach of your image in the form of a tweet to your Twitter followers. Your tweet is composed of the image title and an abbreviated link to the image in your Posterous journal or a web view of your Instagram account. If Twitter followers follow the link and like the image you've posted, they might retweet it to their followers, further extending the reach of your image, while retaining the image destination in your Posterous or Instagram account. I often retweet links to images I like from iPhoneographers I follow as a way of promoting their work to my own Twitter followers.

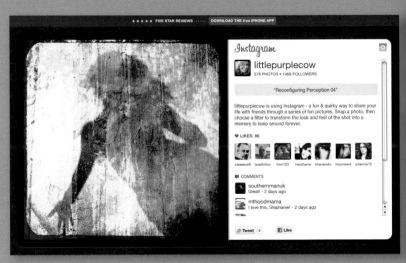

Web view of a link to my image published in Instagram.

Viewing Images Published to Instagram in Twitter

The screenshots here represent a view of the Twitter app.

1 My Twitter profile.

2 My feed of tweets, including auto-tweets generated by Instagram.

3 Followers tap a tweet comprised of the image title, then tap the shortened link to view my image published in my Instagram account.

4 My image published in my Instagram account. Followers can swipe down to view the image title, likes and comments from Instagram users, and tweet or "like" the image in Facebook.

PHOTO SHARING

Share Your iPhoneography With Us

Be sure to join the Flickr group companion to this book:
iPhoneography Art: www.flickr.com/groups/iphoneographyart/

Store, Organize, and Share Your Photos and Collaborate in Flickr

Flickr (www.flickr.com) is an online photo management, sharing, and collaboration website with a companion app to connect with fellow iPhoneographers. You can set up a free Flickr account and expand your service as needed. Using the Flickr app, you can title and tag your images and organize them into sets and collections as you publish them. You might consider organizing your iPhoneography in a single collection, and create specific sets within that collection to archive projects inspired by this book—such as your "Secret Mission" or "Shoot How You Feel" images. What's particularly appealing about Flickr is its flexible privacy settings and collaboration capabilities. You can explore, join, and contribute your photographs and discussions to "Groups" focused on (narrow or broad) shared interests, subject matter, or projects such as the companion Flickr group for readers of this book, "iPhoneography Art."

What's particularly appealing about Flickr is its social networking element. You can connect and follow the images (called "Photostreams") of fellow iPhoneographers by adding them as "Contacts." You can also explore and join photography "Groups." Groups are comprised of Flickr members contributing their select images to a group pool around a shared interest, topic, or project. Conducting a search for iPhoneography Groups yields more than 750 options to explore. Identify and join iPhoneography groups that appeal to your specific interests and contribute your images to these groups to share your vision, get inspired by the images of others, and share feedback. You might consider creating and managing your own Flickr group.

Using the Flickr App

The Flickr app displays your photostream of thumbnail images. Tap an image to enlarge the view, see its title, and reveal comments from fellow Flickr users. You can download and use the Flickr app on your iPhone to upload and share your images directly from your iPhone image library. Using the app you can title the image, add a description, designate the set destination (or create a new one), add tags, set image resolution and privacy settings, and upload your images. Many other photography apps also offer dynamic image publishing from the app to your Flickr account.

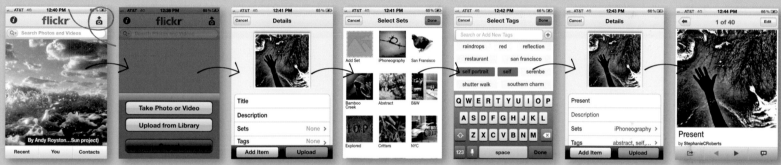

1 Using the Flickr app, you can title your photo, add a description and location, designate the image size and set destination (or create a new one), add tags, choose privacy levels, and upload the photo to share it.

2 Tap the camera icon to take a photo or upload a photo from your library to your Flickr account.

3 Select the photo from your photo library, then specify details such as a title and/or description, and privacy level. Tap "Sets" to place the image in an existing set of photos or create a new set destination. Tap "Tags" to select and assign tags used previously or add new tags.

4 Browse your existing sets of photos and tap one to select or add a set.

5 Browse your existing tags and tap one or more to assign tags to your photo or add a new tag.

6 Tap "Upload" when you are ready to publish, or tap "Add Item" to return to your photo library and find a new photo.

7 The photo appears in your Flickr image feed.

PHOTO SHARING

Exchange Discoveries and Observations with iPhoneographers on Twitter

Twitter (www.twitter.com) is a simple yet powerful micro-communication networking and information-sharing tool that can be used to connect you with a growing community of iPhoneographers and iPhoneography resources. You can access your Twitter account and see status updates from the Twitter users you follow from your computer or via one of several apps available for your iPhone. Because each status update ("tweet") is limited to 140 characters, Twitter users are required to be succinct in their communication, including shortened links (or URLs) in a tweet when there is a desire to share or promote images, blog posts, or other online resources to followers.

Twitter app screen displaying my profile.

Twitter app screen showing list of iPhoneographers I follow and their tweets.

Why Twitter is a Great Companion

As an iPhoneographer you can:

- Find iPhoneographers to follow (to start, refer to the "Explore Resources" chapter for a list of seasoned iPhoneographers and their Twitter names).

- View tweeted images and discoveries from iPhoneographers you follow and share the ones you like by retweeting them to your followers.

- Share your images by tweeting a shortened link to an image published in your online journal or Instagram or Flickr account.

- Share information about your iPhoneography approach by including tags in your image tweets to let your followers know what apps you used to create an image. For example, if you created an image using the **Cameramatic** app, you might include "#cameramatic" in the tweet so that when a Twitter user conducts a search to see "cameramatic" images, your tweet will appear in the Twitter stream. As a result, a new Twitter user might discover your work and choose to follow you.

- Tweet or receive new discoveries such as app finds, image-editing tips, or iPhoneography education or competition opportunities from users you follow.

- Create lists of iPhoneographers and iPhoneography resources you follow to share with your Twitter followers.

- Open the door for a community of people around the world to find you and follow your vision.

Edit and Share Photos with the Facebook Camera App

Use the Facebook Camera app to make quick edits to photos you want to share with your Facebook friends. Though not ideal for comprehensive photo editing, the Facebook Camera app makes it easy for you to make basic image adjustments, add a filter to adjust the look and feel of your photo, tag your subjects, and/or select and upload batches of your photos from your photo library to your Facebook account. When your picture appears within your Facebook photo album, Facebook Camera users and your Facebook friends will be able to view, tag, like, and comment on your images.

Be sure to review the Facebook Camera app's user terms and conditions, as well as the terms and conditions identified by other photo hosting /apps and websites, to ensure you are well informed of your image rights and the rights you grant to third parties when you agree to use their services.

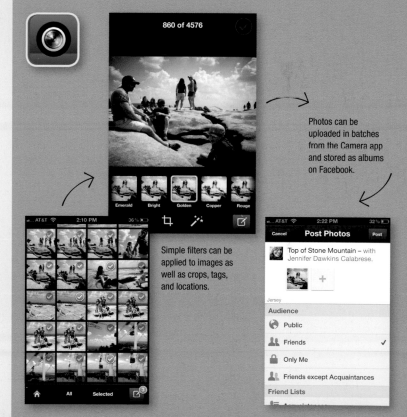

Photos can be uploaded in batches from the Camera app and stored as albums on Facebook.

Simple filters can be applied to images as well as crops, tags, and locations.

EXPLORE RESOURCES

Join the Art of iPhoneography Flickr group
www.flickr.com/groups/iphoneographyart/

For news and updates on this book visit
www.artofiphoneography.com
www.facebook.com/artofiphoneography

Websites Featuring Images, News, App Reviews, and Contests

EYE'EM—http://eyeem.com/

Pixels: The Art of the iPhone—http://pixelsatanexhibition.com/

iPhoneography—http://www.iphoneography.com

Mobile Photography Awards—http://mobilephotoawards.com/

iPhone Photography Awards—http://www.ippawards.com/

Life in LoFi—http://lifeinlofi.com

iPhoneographers to Follow

Get inspired by following the iPhoneographers featured in Chapter 5: Find Your Focus, as well as this list of seasoned iPhoneographers as they experiment, learn, and share their results in real time.

iPhoneographer	Twitter	Instagram
Sion Fullana	@sionfullana	@sionfullana
Greg Schmigel	@justwhatisee	@justwhatisee
AikBeng Chia	@aikbengchia	@aikbengchia
Anton Kawasaki	@anton_in_nyc	@anton_in_nyc
Oliver Lang	@oggsie	@oggsie
Jim Darling	@mr_darling	@mrdarling
Michael "Misho" Baranovic	@MishoBaranovic	@mishobaranovic
Star Rush	@StarRush360	@starrush360
Daniel Berman	@Reservoir_Dan	@reservoir_dan
Jordi V. Pou	@JordiVPou	@jordivpou
Ryan Marshall	@thepanicroom	
Aurora Michavila	@auroramichavila	
Dan Cristea	@KONSTRUKTIVIST	@konstruktivist
Richard Koci Hernandez	@koci	@koci
Meredith Winn	@camerashymomma	@camerashymomma
Benedicte Guillon	@iphoneographic	@iphoneographic

To follow updates from these tweeting iPhoneographers, visit:

Twitter—http://twitter.com/[insertnamehere]

Primary Resources Identified in this Book:

iPhone Photography Apps

Photoshop Express
http://mobile.photoshop.com/

TiltShiftFocus
http://dev-lux.com/tiltshiftfocus/
Twitter: globexcorp

Photo fx
www.tiffen.com/photofx_homepage.html
Image Gallery on Flickr: http://www.flickr.com/
groups/tiffenphotofx/

Hipstamatic
http://hipstamaticapp.com/
Image Gallery on Flickr: http://www.flickr.com/
groups/hipstamatic/
Twitter: hipstamatic

Lo-Mob
http://lo-mob.com/
Twitter: lomobcom
Image Gallery on Flickr: http://www.flickr.com/
groups/1304825@N22/

Mill Colour
http://www.the-mill.com/colourapp/
Image Gallery on Flickr: http://www.flickr.com/
groups/1083518@N25/

ShakeItPhoto
http://shakeitphoto.com/
Image Gallery on Flickr: http://www.flickr.com/
groups/1077237@N20/pool/
Twitter: ShakeItPhoto

Perfectly Clear
http://www.athentech.com/iPhone.html

Iris Photo Suite
http://ventessa.com/Iris/Home.html
Image Gallery on Flickr: http://www.flickr.com/
groups/irisphotosuite/
Twitter: VentessaDevFeed

Camera Plus Pro
http://www.globaldelight.com/
Twitter: GlobalDelight

Camera+
http://campl.us/

Camera Awesome by SmugMug
http://www.awesomize.com/
Image Gallery on Flickr: http://www.flickr.com/
groups/camera_awesome/

TiltShiftGen
http://labs.artandmobile.com/tiltshift/
Image Gallery on Flickr: http://www.flickr.com/
groups/1453968@N22/

Filterstorm
http://filterstorm.com/
Image Gallery on Flickr: http://www.flickr.com/
groups/1699242@N20/
Twitter: filterstorm

Diptic
http://www.dipticapp.com/
Image Gallery on Flickr: http://www.flickr.com/
groups/diptic/
Twitter: diptic

Cameramatic
http://www.mudaimemo.com/iphone/cameramatic/
Image Gallery on Flickr: http://www.flickr.com/
groups/cameramatic/

Snapseed
http://www.snapseed.com/
Image Gallery on Flickr: http://www.flickr.com/
groups/snapseed/
Twitter: snapseed

Online Photo Publishing Platforms and Social Networks

Posterous
http://posterous.com/
Twitter: posterous

Tumblr
http://www.tumblr.com
Twitter: tumblr

Flickr
http://www.flickr.com/
Twitter: flickr

Instagram
http://instagr.am
Twitter: instagram

Picasa
http://picasa.google.com/

Facebook
http://www.facebook.com/
Twitter: facebook

Twitter
http://twitter.com/twitter
Twitter: twitter

Google+
https://plus.google.com/
Twitter: google

Pinterest
http://pinterest.com/
Twitter: pinterest

GLOSSARY

Aperture—the opening of the camera through which light passes. The size of the aperture, depending on the focal length of the lens, impacts the area of focus and the amount of light passing through the camera. While the iPhone camera aperture is fixed, some photography apps simulate depth of field controls that could be achieved by controlling the aperture setting of an SLR camera.

App—an abbreviation for application. An app is a software program that runs on a mobile device such as an iPhone.

App Store—Apple's online source for apps. An iPhone user visits the App Store to browse, purchase, download, and/or update apps on his or her iPhone.

Cropping—the act of eliminating space or removing part(s) of an image to improve composition, reduce image size, or change aspect ratio. Cropping can be adjusted with most photography apps.

Depth of field—the portion of an image that appears sharp. A large depth of field or deep focus places the entire scene in focus. A shallow depth of field emphasizes the subject, and de-emphasizes or blurs the background. Depth of field can be simulated and adjusted with some photography apps.

Exposure—the amount of light used to create an image. An overexposed image is created with excessive light, resulting in loss of detail, a washed-out appearance and blown-out highlights (solid white areas). An underexposed image is created with minimal light, resulting in a dark image with excessive shadows. Exposure can be adjusted with most photography apps.

Facebook—a popular social networking utility used by hundreds of millions of users, and operated and owned by Facebook, Inc. The Facebook website and app enable individuals, groups, organizations, and businesses to connect and share information and content (including photographs) with each other online.

Filters—automated, digital visual effects that adjust the color, texture, aspect ratio, and/or style of photographs. Filters might adjust one or multiple aspects of an image. For example, one filter in a photography app might apply preset saturation, contrast, and vignette adjustments.

Flickr—a popular image hosting utility with a social networking element, operated and owned by Yahoo!. The Flickr website and app enable individuals and groups to connect and share information, photographs, and videos with each other online.

Google+—a popular social networking utility provided by Google. It enables individuals to consume and share information with people organized by "circles" such as friends, family, acquaintances, or categories you define.

Instagram—a photography app and social network owned by Facebook for mobile photographers and photo enthusiasts to share, browse, view, and exchange feedback on photographs among followers.

iPhoneography—the art or process of shooting and/or processing photographs with an iPhone.

Native camera—the built-in iSight camera app pre-installed on the iPhone.

Perspective—the way in which objects appear to the eye based on their spatial attributes. Perspective also refers to the photographer's position and chosen depth of field relative to the composition.

Photo Library/Image Library—the "Photos" app preinstalled on the iPhone. It stores albums comprised of all images on the iPhone. With this app, users can view, select, edit, present, share, copy, and delete images on the iPhone.

Picasa—a popular image hosting and editing utility operated and owned by Google.

Pinterest—a community-based online bulletin board where users "pin" and organize content of interest, such as photographs, on personalized pinboards to share with their followers.

Posterous Spaces—a popular easy-to-use blogging platform (or online journal) owned by Twitter that allows users to post and share text, images, videos, and audio privately or publicly. iPhoneographers can publish photographs to their Posterous sites using email or the Posterous app.

Processing—a method of editing images in a variety of creative ways that might include one or more of the following: cropping; making adjustments to exposure, contrast, saturation, definition, sharpness, or white balance; or applying vignettes, filters, or textures to images.

Saturation/desaturation—the intensity of color. A saturated color is vivid, while a desaturated color is more muted or closer to gray. Saturation/desaturation can be adjusted with most image-processing applications.

Social network—a structure or tool used to connect or display connections and information and/or content between individuals and/or groups based on interdependency, commonality, or mutual interest.

Tumblr—a popular easy-to-use blogging platform (or online journal) that allows users to post and share text, images, videos, and audio privately or publicly. iPhoneographers can publish photographs to their Tumblr sites using email or the Tumblr app.

Twitter—a popular social networking utility and microblogging service owned and operated by Twitter, Inc. The Twitter website and apps enable individuals to share information with followers in the form of 140-character "tweets."

Viewfinder—the component of the camera that the photographer looks through to compose, and in most cases to focus, the image.

Vignette—visual effect showing loss of clarity (i.e. blurring or darkening) toward the outer edges of an image. This processing technique lures the viewer's eye toward the center of the image. A vignette can be applied using most image-processing applications.

INDEX

Explore Resources

Index

Acknowledgments

A photographer is nothing without a subject. Thank you to my family and friends for allowing me to focus on you and make your image.

Adam Juniper, thank you for saying "yes" to this book and paving a path for it. Natalia Price-Cabrera and Tara Gallagher, thank you for boundaries and guiding the production process. Carey Jones, thank you for your thoughtful suggestions and critical eye.

Dixon Hamby, Bob Sprankle, Charlotta Kratz, Keith Weaver, France Freeman, Tom Ward, Dominique Jost, Max Berkowitz, and Jesse Wright, thank you for sharing your insight and images in this book. You inspire me.

Tracey Clark, Jen Lemen, and Karen Walrond, thank you for your encouraging words. You push me in the best way.

Photography app creators and web-tool providers, thank you for giving us permission to feature your products in this book. Fellow iPhoneographers, thank you for sharing your images and discoveries with me online each day. I'm grateful for your contribution to this exciting movement.

And thank *you* for holding this book. I hope it inspires you to hand it to someone else, and go create.

http://www.littlepurplecowproductions.com
Twitter: littlepurplecow
Instagram: littlepurplecow

About the Author

Stephanie Calabrese Roberts is an award-winning documentary photographer, writer, and the creator of LittlePurpleCow Productions. She balances client assignments with a focus on personal documentary projects and Lens on Life, Inc., a nonprofit organization she founded to provide photography education to children and young adults living in challenged conditions or material poverty. Stephanie is a partner in and regular contributor to Shutter Sisters, the most popular online women's photography community. She is the author of *Lens on Life: Documenting Your World Through Photography*, and co-authored *Expressive Photography: A Shutter Sisters' Guide to Shooting from the Heart*. A social media and technology enthusiast, Stephanie explores the power of iPhoneography as a creative and mobile method of visual documentary on a near daily basis.

Apps by the publisher

If you enjoyed this book, why not check out the publisher's apps page?
www.web-linked.com/apps